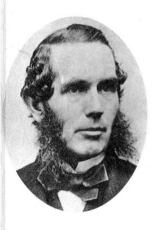

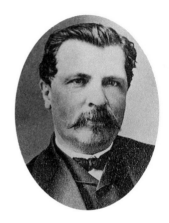

NATHANIEL CURRIER (1813–1888)

JAMES M. IVES (1824–1895)

THE Great Book OF

Currier & Ives' America

BY WALTON RAWLS

ABBEVILLE PRESS · PUBLISHERS

NEW YORK · LONDON · PARIS

For M. L. R., A. W. P., and A. H. R.

All of the illustrations in this book, except one, come from the Harry T. Peters Collection, the world's largest and finest assemblage of Currier & Ives lithographs. They are reproduced through the courtesy of the Museum of the City of New York.

Library of Congress Catalog Card Number: 79-89549 ISBN: 1-55859-229-6

First edition Tiny Folios™ format

CONTENTS

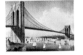

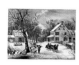

"Be it ever so humble,
there's no place like home"

"Thou, too, sail on, O Ship of State!
Sail on, O Union, strong and great!"

"Go forth, under the open sky,
and list to Nature's teachings."

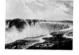

"...America is a poem in our eyes:
its ample geography dazzles the imagination"

"Never was such horseflesh as in
those days on Long Island or in the City"

"...ev'ry prospect pleases,
and only man is vile"

"The Grand Central Depot
for Cheap and Popular Prints"

(Established 1834)

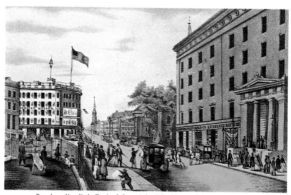

Broadway New York. Currier & Ives, undated. Looking south from City Hall Park.

M ANY AN AFTERNOON in the 1850s, tall, slim Nathaniel Currier might look up from the high desk at the rear of his bustling print emporium and nod to Congregationalist minister Henry Ward Beecher as he thumbed through the latest religious and temperance pictures. This abolitionist firebrand was often in the company of another strong-minded antislavery–antidrink spokesman, Horace Greeley, editor and founder of the nearby New York *Tribune*. Although they intermittently hectored Currier to produce antislavery prints for their consuming cause, his earlier venture into this partisan fray ("Branding Slaves on the Coast of Africa Previous to Embarkation") had convinced him that a smart businessman avoids taking sides—his numerous customers in the slaveholding South were too valuable to risk alienating.

Glancing past these two warhorses, Currier might also greet several other regular customers leafing through prints in the well-stocked bins lining his walls, the upper reaches of which displayed oil paintings he had bought to reproduce as lithographs—all now marked with price tags for quick sale. Through the front door of his shop at the corner of Nassau and Spruce streets, Nat

could see New York's handsome City Hall, and he was quite pleased to be so close to the center of America's largest and busiest city, a burgeoning metropolis with a population well over half-a-million at mid-century. Currier's advertisements stressed that his store was "nearly opposite City Hall," and if he walked to its front entrance, past the crowds standing at the center tables stacked with lithographs of every sort (hand-colored but also available plain), past additional tables on the sidewalk piled with "Cheap and Popular" prints bearing his "N. Currier, Lith." imprint ("20 cents each, or six for $1.00"), he was within a few steps of the pleasant park in front of City Hall known as the Common. Nassau Street, onto which Currier's store opened, had linked the Common and the oldest part of the city since the late-seventeenth century and was one of the streets named to honor Dutch prince William of Orange-Nassau, who with his wife Mary, daughter of James II, ascended the throne of England in 1689.

Along the opposite side of the park was Broadway, a much grander avenue, where, three doors north of venerable St. Paul's Chapel, stood the former residence of John Jacob Astor (at his death in 1848 the richest man in America). To the south, where City Hall park came to a point at Broadway and Ann Street, was the fabulous American Museum, under the entrepreneurship of showman Phineas Taylor Barnum, Currier's great friend and sometime collaborator. Back to the north on Broadway, near Grand Street, was Mechanics' Hall, where the snappy Christy's Minstrels had been playing for years; and if there were ever two things impressionable visitors to New York would never miss, they were the minstrels and Barnum's extravaganza (later billed as "The Peerless Prodigies of Physical Phenomena and Great Presentation of Marvelous Living Human Curiosities"). On Fulton, the next street behind the Barnum museum, were the showroom and workshops of another of Nat's friends, Duncan Phyfe, the city's premier furniture-maker. The Scotsman Phyfe had made a substantial success of himself in his adopted city, just as the Massachusetts-born Currier had.

It was a great time to be alive (and in business), for it seemed that hardly a month passed that a wily New Yorker did not invent or perfect something that would amaze the Old World and radically change life in the New World—or that some intriguing disaster suitable for one of Currier's "rush prints" did not befall the city's many inhabitants. Nat could also number himself among the innovators: his disaster prints, rushed out within days of a bloody catastrophe (and showing its every gory aspect), were the world's first illustrated news "extras"; he also liked to take credit for originating the "political banner," a vote-getting necessity in all future elections. This colorful type of print featured inspiring portraits of a party's candidates, its slogan, and a few surefire symbols like the American eagle and arrays of Stars and Stripes.

Also on Fulton Street (formerly Partition, but renamed for the New York inventor of the practical steamboat), at the corner of Broadway, was the prosperous establishment of another well-known innovator—whose latest line of work was destined to hasten the eventual demise of

commercial lithography. Of course Nat Currier did not dream that the achievements of Mathew B. Brady with the newly invented photograph would have this melancholy effect, any more than he anticipated the ultimate success of experiments by other lithographers in applying color to a print mechanically while printing it, rather than coloring it later by hand—as had been done so beautifully in his factory for more than twenty years. Nathaniel Currier, the most successful lithographer and printseller in the entire country, was more than content with the technical operations of his company, and he was never, in the quarter-century of printmaking left to him, to install the equipment for doing what came to be called chromolithographs, or "chromos."

Mathew Brady had started out in business life as a lithographer, but he had taken an early interest in the promising "heliographic pictures" of the Frenchman Louis-Jacques Daguerre (formerly also a lithographer) and had opened a Daguerreotype studio on Broadway about 1842. His specialty was portraits (a big item for Currier's income as well), and in 1850 he had published a patriotic volume called *The Gallery of Illustrious Americans, containing Portraits and Biographical sketches of 16 of the Most Eminent Citizens in the American Republic, since the Death of Washington. From Daguerreotypes by Brady.* Of course the portraits ultimately had been lithographed for the book (by Francis D'Avignon, who in the 1840s had done work for Currier), so the new way of taking portraits did not immediately appear to be a threat to lithography. Besides, Nat Currier thought it more suitable to take likenesses of his distinguished subjects from drawings and paintings by gifted artists, who could capture a worthy's "character" in addition to his surface topography. However, one of the best of his early staff artists, Napoleon Sarony, who had opened his own lithography business in 1846, was then showing a strong interest in this new technique of portraiture and eventually would become a portrait photographer of considerable renown. By 1855 Brady had already abandoned the Daguerreotype for the even-newer wet-plate photograph, and, after that, the source of many a lithographed portrait was sure to be an original picture taken by Brady—including Currier's own "beardless" Lincoln issued in 1860.

Before turning back from the edge of City Hall park toward his shop, Nat Currier might have gazed directly ahead of him for a few moments at the changes made in the former John Jacob Astor residence, now a hotel called The Astor House and the haunt of local politicians. Another notable gathering spot for politicians, government officials, and hangers-on was a block north of Currier's store, on Nassau Street at the corner of Frankfort: the first Tammany Hall, home of the Society of Tammany or the Columbian Order of the City of New York. This four-story, red brick edifice, built in 1810, was, at the time, one of the most imposing buildings in the entire city. Its halls had yet to echo loudly with the name of William Marcy Tweed (former chair manufacturer at 325 Pearl Street), but he was already, at mid-century, alderman of the seventh ward. Nat Currier, in doing his civic duty, would have run into him regularly at the frequent fires in the older stretches of the city, for they were both volunteer firemen—Tweed being foreman of the Volunteer Fire Company

"Americus," whose famous engine "Big Six" was embellished with the painted head of a snarling tiger that "Boss" Tweed would appropriate as his private symbol.

If Nat looked south on Nassau Street, down a few blocks, near Liberty (Crown Street until the Revolution!), he could see the bulbous steeple that marked the post office he had quickly learned to make good use of, since a growing portion of his business was solicited by mail through form letters and catalog sheets— "Any of the Prints on this Catalog will be sent by mail, free of postage, at the prices named, cash to be remitted with order." The post office building was then well over one hundred years old, having been the Middle Dutch Church from 1731 up to the year 1848, when the U.S. government had leased it and remodeled it a bit for conducting a different set of services. That building was nearly the last link, at mid-century, to New York's ancient Dutch past (the city's final sermon in the Dutch language was preached there in 1764). The terrible fires of December 16th and 17th, 1835, had destroyed some six hundred buildings below Wall Street and effectively burned away all traces of the quaint New Amsterdam Nat Currier had admired on his arrival in New York just the year before the fire. Nevertheless, young Nat was to discover that one could mine a silver (even gold!) lining from beneath the dark clouds of every disaster, for that conflagration had provided him with the subjects for two good-selling "rush prints": "Ruins of the Merchant's Exchange . . ." and "View of the Great Conflagration . . . from Coenties Slip." As a matter of fact, "Ruins of the Merchant's Exchange" and another disaster print of 1835, "Ruins of the Planters Hotel, New-Orleans . . ." (a visualization strictly imaginary since neither Currier nor his artist J. H. Bufford had been there), were Nat Currier's first substantial successes—in a vein of gold he was to mine profitably for many years.

In 1840, his sixth year in business, Currier had achieved nationwide recognition for his imprint with the publication of "Awful Conflagration of the Steamboat LEXINGTON in Long Island Sound on Monday eve, Jany 13th, 1840, in which melancholy occurence over 100 PERSONS PERISHED." This time Nat Currier combined resources with his friend Benjamin H. Day, who had founded the penny paper New York *Sun* in 1833 and built it into the best-selling daily in the world—largely through such circulation-boosters as the famous "Lunar Temples" hoax of August 21–23, 1835. In mock scientific language, the *Sun* had announced that the eminent astronomer Sir John Herschel had "solved or corrected nearly every leading problem of mathematical astronomy," and from the new perspective on the moon at his observatory near the bottom of the world (the Cape of Good Hope) he had discovered extensive hitherto-unknown flora and fauna on that satellite—including "men" with wings like bats'. The newspaper's subsequent sales were phenomenal, and the series of articles was quickly reprinted as a pamphlet with fanciful lithographed illustrations of the sightings—which sold 60,000 copies in a month!

When the first news of *Lexington*'s disastrous fire reached the *Sun*, Currier happened to have been in the paper's office and to have gotten the brainstorm of illustrating the "extra" that surely

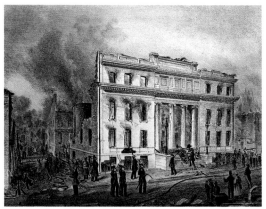

Ruins of the Merchant's Exchange, N.Y. Nathaniel Currier, 1835.

would be issued as soon as more details came in. After all, the *Lexington,* built in 1835 by Cornelius Vanderbilt, was the best-loved of all Long Island Sound steamboats to have served that favorite passenger route from New York to Boston (since the War of 1812), giving many a morbid New Yorker cause to sigh, "There but for the grace of God go I!" Rushing back to his nearby workshop, Currier set the artists Napoleon Sarony and W. K. Hewitt to work on a large lithograph stone and continued to supply them with fresh details as the story became clearer from eyewitness reports. Under a heading, "THE EXTRA SUN," Sarony and Hewitt drew a broadside view of the *Lexington* aflame, with dozens of passengers struggling for their lives in the icy Sound. Beneath that they sketched a map showing the spot off Eaton's Neck, Long Island, where Captain Hilliard had tried to beach the blazing leviathan but had lost control when his rudder ropes burned through. The rest of the space on the stone was left for the news story *Sun* reporters were putting together throughout the evening. In a day or so, the first inked impressions of the lithograph stone were on the streets—an unprecedented feat—and the public demand was sensational. The Currier work-

shop pulled print after print of the disaster, and orders continued to pile in from near and distant parts while another stone was prepared for issuing with a firsthand report of the tragedy by Captain Hilliard, among four to survive out of 150 voyagers. Later, the print alone, luridly hand-colored with simulated tongues of flame, was to join the roster of what Currier called "stock prints": pictures of every imaginable subject (except the salacious), kept available as long as orders for them flowed into "The Grand Central Depot for Cheap & Popular Pictures"—as one of Currier's letterheads identified his shop.

Oddly enough, the highly successful partnership of the New York *Sun* and "N. Currier, Lith." in putting out an illustrated, sensational news story in the quickest time ever was not continued or repeated. But it was not for lack of suitable local marine catastrophes: on April 17, 1845, the Hudson River steamer *Swallow* went down to the bottom, taking a reported forty lives; on May 18, 1849, the *Empire* sank with a loss of twenty-four passengers; and, near Yonkers, New York, on July 25, 1852, the *Henry Clay* burned to its waterline, with sixty fatalities (including the well-known architect Andrew Jackson Downing)—nor did the alert Nat Currier fail to memorialize these disasters as stock prints for the morbid sector of his audience! The true reasons for never revivifying this unique partnership are unknown, but a falling out between the two principals was probably not a factor, since the newspaperman's son, Benjamin H. Day, Jr., worked as a lithographer–printer in the Currier shop. Again, Nathaniel Currier, lithographer par excellence when it came to picking popular graphic subjects and selling them, had unwittingly nurtured the developer of a new technical innovation that would contribute to making his beloved lithography obsolete before the nineteenth century ended. It was this very Ben Day who invented a type of screened dot pattern (now called benday) that automatically breaks up the continuous tone of a photograph and permits it to be printed in a book or magazine like a simple line engraving or type—without the previously necessary step of redoing the picture as a lithograph or of engraving it on the end-grain of a boxwood block.

I N 1828 THE PROMISING EUROPEAN INVENTION called lithography was barely twice the age of fifteen-year-old Nat Currier, who that year began an apprenticeship in the Boston shop of William S. and John Pendleton, America's first successful lithographers. The Pendletons themselves had been in the business for just three years—and in it because they had advantageously purchased stones and lithographic equipment from an importer who had no idea what to do with them. It had all begun in Munich, Bavaria, with a laundry list that young Alois Senefelder had jotted down for his mother. The son of an actor and determined to become a great playwright,

Senefelder, who was born in Prague, had experimented for some time with methods of cheaply reproducing his dramas for public circulation—since the expense of setting type and of commercial printing was far beyond his modest circumstances. He had tried many unusual techniques of printing, including that of engraving and etching his dramatic dialogue onto randomly acquired steel, zinc, and copper plates and then by taking clay impressions of his deep-etched words cheaply creating imitation type in relief for printing by hand. Nothing quite worked satisfactorily—nothing that a poor actor's son could afford. Then one day in 1798, while busy with yet more experiments, he was asked by his mother to help her by writing down the laundry list as she called out the articles of clothing. For lack of an available pencil and paper, Senefelder picked up a hardened piece of his homemade printing ink (a combination of wax, soap, and lampblack) and recorded each soiled item on a handy block of limestone from the nearby Solnhofen quarry

Later, having dutifully copied the list onto something less monumental, he decided to experiment with the stone before cleaning off his waxy markings. He wondered whether a relief printing plate could be made from stone, whether aqua fortis, or nitric acid, would eat away only the unwaxed areas—as he knew it would on metal—leaving his mother's laundry list in high-enough relief to print. In washing off the spent etching acid, which did indeed give a slight relief to the wax-protected list, he noticed that water ran rapidly off the greasy letters while it soaked into the pores of the stone not sealed off by wax. That oily, greasy substances will not mix with water doubly impressed him as—eager to try printing it—he inked the still-wet stone and saw ink build up on his lettering without sticking to damp areas of the stone. Beads of black viscid ink wiped right off the wet surface but adhered to the similarly greasy waxed list—clear evidence of the natural principle that was to be the basis for all future types of planographic reproduction. By putting the inked stone in an old copperplate printing press, laying a sheet of paper on it, and cranking down the heavy platen to exert even pressure on the paper, Alois Senefelder succeeded in producing the world's first lithograph—a lowly itemization of the family's dirty clothes for the week (in mirror image).

Senefelder finally had invented a practical and truly inexpensive process for printing his plays. Indeed, by keeping the stone wet before inking it again and again, he found that he could take as many impressions of a page of his dramatic works as he wished, but never again was he to have the time for doing that. First he had to overcome the inherent difficulty of writing the many pages of his texts on the stone in reverse, so they would be "right-reading" when printed. Eventually Senefelder found that by drawing an image in greasy crayon on a sheet of paper dipped in a thin gum solution he could transfer that image in reverse by laying the paper face-down on a dry stone and applying pressure. The results were not as satisfactory as direct work on the stone—not so dark or sharp—but the image thus transferred could then be touched up and strengthened without the unwelcome challenge of correctly writing each separate letter backwards.

After a time, Alois Senefelder had so perfected the process of printing from stone that it hardly has been necessary to improve upon his techniques since then. Even the Solnhofen-quarried stone that Senefelder reached for by chance that day has not been found to have a superior. As in Senefelder's day, this very porous calcareous slate is drawn on while dry with sharpened crayons (of varying degrees of hardness and diameter) composed of the same basic elements (wax, soap, and lampblack) used in his homemade ink. The stone is then subjected to a timed etching with a solution of aqua fortis that leaves the drawing or lettering in slight relief (gum arabic is added to aid the stone's absorption of grease and to make drawn-on areas more resistant to water). To "pull" a print, the stone is wet thoroughly, greasy ink is rolled repeatedly onto the surface until there is sufficient build-up on the waxy image, and, finally, all traces of ink are wiped from the wet, nonprinting areas. A dampened sheet of paper is placed carefully onto the inked stone, and then great pressure is applied in a press to transfer the print's image from stone to paper.

JOHN PENDLETON SEEMS TO HAVE BEEN a restless sort. A year after Nat Currier had gone to work for the Pendleton brothers in Boston, John had formed a partnership in Philadelphia with Francis Kearny and Cephas G. Childs (who later founded the *Philadelphia Gazette*), lithographing under the Pendleton, Kearny & Childs imprint. Nevertheless, the year 1831 found Pendleton set up in business for himself at 137 Broadway in New York City, with young Alexander Jackson Davis (destined to become one of the most influential architects of the era) drawing on stone for him. Davis had worked earlier for William Pendleton in the Boston firm, and by 1831 it was operating four lithographic and four copperplate presses—manned by three apprentices: Nat Currier, John W. A. Scott (from 1840 to 1847 to be in partnership with FitzHugh Lane, later a well-known marine painter), and Benjamin F. Nutting.

In 1833 Nathaniel Currier was himself to leave Boston for Philadelphia, to work with M. E. D. Brown at 5 Library Street, presumably on the many scientific plates Brown prepared for the *American Journal of Science and Arts*. Within a year Currier had moved to New York, expecting to follow his trade in the employ of his former mentor, but John Pendleton was anxious to move again. In 1834, he arranged to sell his business at 137 Broadway to the journeyman lithographer Nat Currier, then twenty-one years old, and a man named Stodart, who probably was the same fellow who had operated a music publishing business at 167 Broadway under the name of Dubois & Stodart. At any rate, there are several extant music sheets of 1834 and 1835 bearing the Stodart & Currier imprint, of which the earliest seems to be "The New York Light Guards. . . ." The print now regarded as the earliest-known important American view with the name Currier on it,

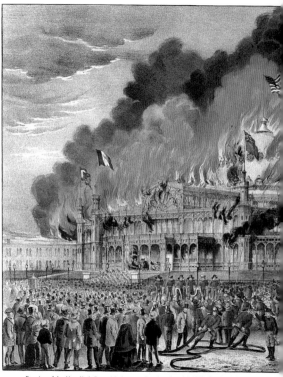

Burning of the New York Crystal Palace, on Tuesday, Oct. 5th 1858. Currier & Ives, undated.

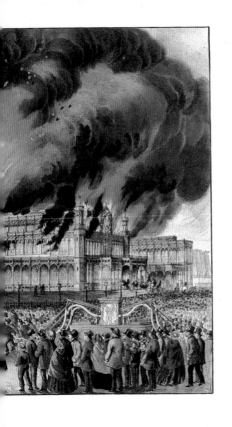

"Dartmouth College," also bears the imprint of Stodart & Currier in its first state, and, like the similar views of Mount Holyoke and Upper Canada College (the earliest-known colored print by Currier), was probably commissioned by some loyal alumnus.

Currier and Stodart had been trained as job printers; they duplicated anything a customer needed numerous copies of, be it label, letterhead, handbill, architectural plan, portrait, or view of the old school so fondly recalled by its graduates. Nevertheless, the new partnership did not prosper to the satisfaction of Mr. Stodart, and sometime in 1835 he pulled out. The company then became N. Currier, Lithographer, with new, temporary quarters at No. 1 Wall Street.

Before he hit upon the very profitable idea of offering the American public vicarious experiences of disaster, Nathaniel Currier continued on with the usual work of a lithographer, including the printing of architectural plans for Alexander Jackson Davis, who was at that time building the Customs House on the corner of Wall and Nassau streets (the site of Washington's inauguration), now the Federal Hall National Memorial. One of the earliest lithographs to bear the new imprint is the rather graceless multiple portrait "Dr. William Valentine in some of his Eccentric Characters." Although the print is not dated, Valentine, a recognized thespian with a variety of dramatic personas, is only known to have performed in New York City, at the Park Theater, during the 1834–35 season. There is an earlier portrait, "Wm. P. Dewees, M.D.," actually dated 1834 and bearing the N. Currier imprint in an early state, that is probably the first of all lithographs to bear this distinguished imprint, and it is certainly the most accomplished portrait ever associated with the Currier name. However, the date is at least a year earlier than Nat Currier was first set up in business with his own imprint. Since the subject was a professor of obstetrics at the University of Pennsylvania (a best-selling author in his specialty), and since the likeness was put on stone by Currier's sometime Philadelphia employer M. E. D. Brown, after a painting gesture by the Pennsylvania artist John Neagle, the imprint must have been something like a parting gesture from Brown, a "letter of recommendation" to show Currier's future employer in New York—even though the only possible role left in the print's creation for Currier (since he was not yet a publisher) would have been as inker and printer.

Even after Stodart had left him, Nat Currier continued to lithograph music sheets for local publishers—creating appropriate and attractive "scenes" especially for the front covers. In 1837 he produced "The Crow Quadrilles," a collection that included the tunes "Jim Crow" (whose title would characterize the Negro segregation laws enacted throughout the country in the 1890s) and "Zip Coon," a song destined to become better known as the hoedown "Turkey in the Straw."

In 1840, Currier lithographed a music sheet with the title "Log Cabin or Tippecanoe Waltz," a contribution by William C. Raynor to the rollicking "log cabin and hard cider" presidential campaign between incumbent Democrat Martin Van Buren and Whig candidate General William Henry Harrison, the hero of Indian warfare thirty years earlier on Tippecanoe Creek in Indiana.

lthough President Van Buren had been Andrew Jackson's vice president and chosen successor,
nd in his first campaign for the presidency had pledged to "tread generally in the footsteps of
resident Jackson," there were those who felt that "Little Van" had abandoned Jacksonian
emocracy for the aristocratic luxuries glimpsed during an earlier diplomatic mission to the Court
f St. James's—a feeling heightened by a widely quoted speech given by Pennsylvania con-
ressman Charles Ogle on "The Royal Splendors of the President's Palace." The Democrats
untered these insinuations of undemocratic tastes in their candidate with the snide assertion that
would take only a barrel of hard cider and a pension to make Old Tippecanoe give up any idea of
ading his log cabin in Ohio for the White House. From that time on, the Whigs abandoned all
sues and centered their campaign on the dispensing of hard cider from portable log cabins, the
houting of their slogan "Tippecanoe and Tyler too!" and the singing of songs that praised the
omespun American virtues of their old hero.

On the fourth of March, 1841, William Henry Harrison was inaugurated President of the United
ates, and, one month later, on the fourth of April, Old Tip was dead—of a cold caught at his
iauguration that grew into pneumonia. This melancholy event did not go unmarked by Nathaniel
urrier, who quickly issued a portrait of the old soldier, standing in a graveyard by a monument
earing his name, his dates, and the term of his presidency, under the heading, "In Memory of."

Encouraged by the success of the President Harrison tribute, Currier was moved to add another
e to his growing inventory of stock prints: the august "In Memoriam"—a tasteful view of a
ell-kept graveyard (most often the cemetery of nearby St. Paul's Chapel) that featured a rather
nposing Greek Revival monument with blank space beneath its inscription ("In Memory of") for
ie name and dates of the decedent to be filled in. To one side of the picture, usually a somber study
dull green and black, there is a family group of mourners looking suitably sad at the loss of their
eloved relative. Another stock-print line catering to the nineteenth century's compelling interest
Death's visitations is Currier's series with titles like "Papa's Picture" and "Mama's Picture,"
lowing a single parent with a toddler—not yet fully aware of the gravity of its loss—lovingly
eld in front of a portrait of the departed spouse and parent. Undeniably touching and appealing as
remembrance for widowers, widows, and children bereft of a parent, this type of print would
ave had special meaning for Nathaniel Currier, whose young wife Eliza had died shortly after the
rth of their son Edward.

In 1850, another president, Zachary Taylor, died in office, and his demise brought forth from
. Currier, Lith. a variation on the "In Memoriam" theme that would henceforth mark the passing
virtually every notable American hero of the nineteenth century: the deathbed tableau, which
irported to capure the great man in his final minutes, surrounded by grieving friends, family, and
ithful retainers, all visibly expecting the worst. This series was only to be outdone by the
ctorial—and marketing!—opportunities opened up by the Civil War's carnage, when newly

called-for symbols, images, and themes challenged the ingenuity of the artists Currier would set to work on inspirational memorials to valor, sacrifice, and death *pro patria*.

E ARLY EACH MORNING, pushcart vendors and backpack peddlers lined up at the door of 152 Nassau Street to take on consignments of Currier's cheaper prints to hawk through the city's streets and in close-by communities such as Brooklyn and Hoboken, both easily accessible by ferryboat. Undoubtedly they were enticed to enter the print field by such sales pitches as the following:

> To Peddlers or Traveling Agents, these Prints offer great inducements, as they are easily handled and carried, do not require a large outlay of money to stock up with, and afford a handsomer profit than almost any article they can deal in, while at the same time Pictures have now become a necessity, and the price at which they can be retailed is so low, that everybody can afford to buy them.

Each night, the weary peddlers would trudge back to the corner of Nassau and Spruce streets to settle accounts for the day—paying wholesale for the prints sold, returning the rest, and retrieving their deposits. The cost to vendors for the small prints (8 × 12 inches to 11½ × 15¾ inches) was six dollars a hundred, or six cents apiece, and their retail price was whatever the traffic would bear—from fifteen to twenty-five cents each. The large lithographs, which more often were handled by regular dealers such as harness shops, general stores, and barrooms, usually retailed in a range from $1.50 to $3.00. (Harry T. Peters, the premier collector of Currier & Ives, secured a number of his fine large prints early in this century from an old harness shop in Newburgh, New York, which still had stock on hand from much-earlier days!)

By mid-century, the prospering Nathaniel Currier had wisely built up his backlist of fast-moving stock prints in a far wider range than disaster and death, having by then developed many additional categories around which the future renown of his growing company would revolve. He had already launched his series of clipper ship prints, had begun creating the historical pictures that would help Americans visualize the soul-stirring events of their heritage, had started issuing the portraits of our founding fathers in standard format, the views of New York City landmarks visitors liked to take back home, the bucolic scenes of farm and countryside the harried city-dwellers looked upon fondly, the likenesses of glittering stars who graced the boards of America's theaters, and the popular and touching sentimental prints of all sorts, including biblical, moral, religious, and temperance themes.

Sales and distribution of the lithographs were in the hands of Daniel W. Logan, Sr., who was to devote nearly forty years to the firm. Managing the operations of the retail store with a staff of about five salesmen (and a boy or two to watch the bargain tables outside), he also directed the bulk packing and shipping to the company's regular agents—including a London office responsible for European sales—and he filled individual orders from all over the country in response to Currier's mail-order solicitations. The enormity of Logan's task is made clear in one catalog of the period that summarizes its contents:

Plain Prints—	1068 subjects
Large Colored Prints—	368 subjects
19 × 24 & 16 × 20 Colored Prints—	268 subjects
Cheap and Popular Prints—	1096 subjects

Nearly three thousand in-print lithographed subjects to keep track of! And, beyond Logan's duties were those of the overall boss Nathaniel Currier who, among other things, had to handle the finances of these transactions, watch the inventory and schedule reprints within the capacity of his workshop, or factory, and also keep his list fresh with a steady infusion of new ideas and timely subjects.

The burden of supervising every detail of a complicated business became onerous for Nat Currier, and, especially after the early death of his wife Eliza, he began to spend more time at his summer home in Amesbury, in his native Massachusetts. He was often in the company of one of his neighbors, the Quaker poet John Greenleaf Whittier, whose voice at that time was constantly raised against slavery—without convincing Currier that abolitionist prints were good for business. It seemed that solitary rides behind a pair of the fine trotters he kept stabled in Amesbury were his only release from the pressures of an expanding business. There is a painting by R. A. Clarke of Currier out driving in the Massachusetts countryside, and the firm published it in 1853 as ''The Road—Summer.'' That was paired with a similar print called ''The Road—Winter,'' which shows Nat again behind his favorite trotters (this time pulling a spiffy cutter over the snow) and seated beside his second wife, Lura Ormsbee, a native of Vermont he had met in Amesbury. This lithograph was done as surprise gift from his staff.

Nat always expected that his younger brother Charles would become his partner in the firm, but the short, rotund Charles seemed unwilling to tie himself down to the practical requirements of regular work. He made his living from commissions on orders he brought to the firm, and from the occasional lithograph he issued under his own imprint, using the 33 Spruce Street address of the N. Currier factory. Eventually, his major source of income was the superior lithographic crayon he invented with the aid of Fanny Palmer, one of Nat Currier's best all-around artists. Although the

lithographic crayons earlier thought best were imported from France, Charles manufactured h highly marketable crayons in the attic of his home at 521 Lafayette Avenue in Brooklyn, much the discomfort of his wife, the former Elizabeth Clark of Keeseville, New York. (It was also at h home in Brooklyn that Charles Currier assembled and stored the only complete set of t lithographs his brother's firm put out over the years. Unfortunately, when the cases were examin after his death, most of the prints had been ruined by the dampness of his cellar.)

One evening, Elizabeth Currier's sister Caroline was introduced to a jovial, young acquaintan of her brother-in-law named James Merritt Ives—a unique combination of amateur artist a professional bookkeeper—and in a short time the two became engaged. However, James Ives fe that an improvement in his income and prospects was necessary before he could honorably mar Caroline; so Charles Currier was persuaded to introduce Ives to his brother Nat. Right away, in t year 1852, James M. Ives was hired as head bookkeeper for the N. Currier firm, and it was not to long afterward that he and Caroline were married, settled in Brooklyn, and on the way producing a family of two sons and four daughters.

James Merritt Ives, a native New Yorker brought up on the property of Bellevue Hospital (whic his father served as superintendent), was then twenty-eight years old, eleven years younger than Nat Currier. Furthermore, he was somewhat the opposite in physique and temperament to his ta pensive, often melancholy employer (who had lost in infancy the only child with his second wife Described by some as "plump," Ives did seem to accumulate more weight than advisable for person of scarcely medium stature, but he was no means heavy and sluggish. Despite the initi misgivings of Nat Currier, Ives immediately proceeded to reorganize (and modernize) the firm system of record keeping, both in the area of its finances and its enormous inventory of prints.

Gradually, Nat Currier came to recognize the results of Ives's improvements in the firm operations and was pleased to find himself relieved of many tiresome chores that formerly bo down on him. Even his sales clerks confessed that with the advent of Ives's systemization the more regularly located the particular prints customers asked for, and only rarely did they no accidentally uncover supplies of prints long thought exhausted. Nat was pleased as well with th initiative Ives took in speeding up the print production process. A self-trained, creative artis James Ives easily sketched out rough ideas in terms the company's artists quickly grasped, and th bookkeeper in him knew how to institute a bit more regularity to the flow of work through th factory. Nor could Currier really complain, after all, about the success of new types of prints Ive had persuaded him to do—prints Nat initially dismissed as "undramatic." Indeed, they simpl presented plain experiences and pleasures of American life and recorded everyday occupation and amusements of honest folk (most often in bucolic settings)—a genre best characterized by th much later series *Four Seasons of Life,* of which "Childhood" and "Middle Age" carry th legend "Painted by J. M. Ives." Currier had not earlier regarded these tableaux as particularl

salable, given his dramatic successes with catastrophe, but James Ives was attuned to subtler vibrations in the air, correctly sensing in the discontent of harried city-dwellers a ready market for inexpensive depictions of what they imagined was a simpler, more fulfilling, more American way of life.

In 1857, Nathaniel Currier made James Merritt Ives a full partner in the fastest-growing firm of printmakers in America, giving birth to a famous trade name still widely recognized three-quarters of a century after its final appearance on a new lithograph: Currier & Ives.

Abolition was but one aspect of a spirit of reform and betterment swelling the American heart in the decades before the Civil War. The American Anti-Slavery Society was founded in 1833, and it developed alongside such other well-intentioned groups as the American Society for the Promotion of Temperance, organized in 1826 as a bulwark against what Lyman Beecher, one of its supporters, called "Sabbath-breakers, tippling folk, infidels and ruff-scruff generally . . ."; and the American Sunday School Union, formed in 1824 to "circulate moral and religious publications in every part of the land" (the American Tract Society, chartered in 1825 with a similar purpose, was located in the same building as Currier's shop); and the American Art Union, founded in 1842 with a program for "the promotion of the fine arts in America" through the widespread distribution of engravings of selected works of art.

Nat Currier did his part for temperance by producing numerous prints contrasting the degradations of drunkenness with the sure prosperity attendant on sobriety, blank certificates for membership in temperance societies, and attractive scrolls spelling out "the Pledge." Furthermore, Currier outdid himself in providing moral and religous pictures for all persuasions, but he left "the promotion of the fine arts" to the Art Union. Nat seemed to be an adherent of the point of view expressed in 1854 by Long Island artist William Sidney Mount: ". . . never paint for the few, but for the many." He never advertised his lithographs as "art," but as "pictures" or "prints"; and he never copied "works of art" to sell as such, but as representations of historical events or personages otherwise unavailable (as in the case of the John Trumbull painting of the Battle of Bunker's Hill or the Gilbert Stuart portraits of the first five presidents of the United States). And Currier never saw his role as elevator of American taste, for he simply characterized his prints in one catalog as ". . . handsomely colored and suitable for framing or for ornamenting walls or panels, the backs of bird cages, clock fronts, or any other place where an elegant and tasteful picture is required."

The "do-gooders" were not able to elevate, direct, or improve the lives of all citizens in the years before the Civil War, although they turned their benevolent attention to as many misguided or unfortunate groups as they could reach, even to the prostitute, the criminal, the desperately ill, the orphan, the blind, and the insane. Characteristically, in a period of growing nationalism and "manifest destiny," reformers all seemed to style their societies "American . . . ," as if their

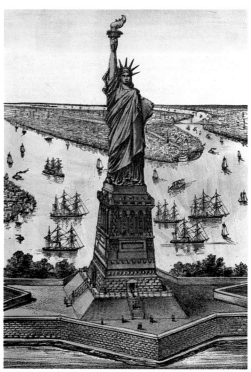

The Great Bartholdi Statue, Liberty Enlightening the World. Currier & Ives, 1885.

campaign were the outgrowth of a purely New World consciousness. Consciousness was rising in other areas of life as well: the woman's rights movement had held its first convention, at Seneca Falls, New York, on July 18th and 19th, 1848—the start of a crusade that Currier & Ives would later satirize in such prints as "Age of Iron" and "Age of Brass," the latter featuring Susan Sharp-Tongue, "The Celebrated Man Tamer."

Anti-Negro feeling was widespread in the North in the decades just before the Civil War—and, as Messrs. Currier and Ives were profitably to discover, just as rampant in the remaining decades of the century. They issued hundreds of prints (listed in their catalogs as *The Darktown Series*) that crudely ridiculed the aspirations of American Negroes to a better life. In the same sense that bucolic scenes of cottages in the woods were appealing and salable to the row-house and tenement dweller, caricatures of Negroes comically failing to master even the rudiments of life in the white man's world were just the right thing to adorn workingmen's saloons and hiring halls—symbolic icons of safe containment of this black threat to their livelihoods. Again Philadelphia took the lead in violence (its anti-Catholic riots having been the worst in the century), with bloody racial incidents flaring up there as early as the summer of 1840. In New York, tempers were restrained a bit longer, but abolition rallied very few active supporters among businessmen with Southern markets or among the Irish-American working class—who showed little interest in improving the status of Negroes. As Catholic Archbishop Hughes was to warn the War Department in the early days of the Civil War, his coreligionists were "willing to fight to the death for the support of the Constitution, the government, and the laws of the country," but they could not be moved to patriotic sacrifice by an abolitionist scheme to free Southern slaves.

A CURRIER & IVES CATALOG OF THE 1870s explained that long experience in the lithography trade had made the company "thoroughly acquainted with the wants of the Public, and the best methods of producing GOOD PICTURES at a small expense." The prints were not, of course, made on the premises of the busy retail shop but in a "factory" around the corner on Spruce Street, first at No. 2 (an address the company used as the sole imprint on certain political cartoons—lest someone think the Currier & Ives firm partisan) and then at No. 33, until the dissolution of the venerable concern in 1907.

No. 33 Spruce Street was a five-story factory building, of which Currier & Ives had leased the third, fourth, and fifth floors for producing what another catalog called, "The Best, the Cheapest, and the Most Popular Pictures in the World." The third floor was devoted entirely to hand-powered printing presses based on the Senefelder prototype, and several more of them were set up in the midsection of the fourth floor, which had its Spruce Street side, or front, given over to facilities for

preparing proper drawing surfaces on the lithograph stones. Called "graining," this process was full-time work at Currier & Ives for one man, who had to remove all traces of any previous lithograph on the stone and ultimately produce an even-textured, almost velvety surface that would "take" every nuance of the various crayons used by a lithographer. Basically this was accomplished by grinding one flat stone against another in a circular motion while gradually reducing the coarseness of sand grains sprinkled between the two stones. The rear, or north side, of the fourth floor, where the light was better, was the domain of the artists, lithographers, and letterers.

Most of the best-known artists associated with the Currier & Ives firm over the years were not native Americans nor full-time employees. Only English-born Frances (Fanny) Flora Bond Palmer, whose artistic capabilities ranged from rural American scenery to Mississippi River steamboats, from domestic architecture to flower arrangements, was on the payroll any great length of time—some thirty years. Nathaniel Currier's early associate Napoleon Sarony, who was born in Canada and excelled at historical pictures, left the firm in 1846 to form his own company with Henry B. Major, another Currier employee. At the beginning of the Civil War, German-born Louis Maurer, blessed with a gift for drawing horses and figures, parted with Currier & Ives after eight years to join Major & Knapp, successors to Sarony, Major & Knapp sold out his interests and departed for Europe. Charles Parsons, best known for the famous "Central Park—Winter, The Skating Pond," was brought to this country from England as a child and apprenticed to Endicott & Company, a lithography firm established in 1828. During his thirty years at Endicott, Parsons also handled work, especially marine prints, farmed out to that company by Currier & Ives. In 1863 he became head of the art department at Harper & Brothers, where he employed Thomas Worth, who made his first sale of a drawing directly to Nat Currier. Worth seems to have been the largest single contributor to the Currier & Ives list, having originated almost all of *The Darktown Series.* The remaining artists of note among the regulars—Englishman Arthur Fitzwilliam Tait, highly regarded for his scenes of hunting and fishing in the Adirondacks; George Henry Durrie, without peer in the limning of winter farm life in New England; and James E. Butterworth (also English), who specialized in marine paintings—were never directly employed by Currier & Ives but sold paintings individually for reproduction.

The Currier & Ives lithographers, whose job it was to recreate selected sketches and paintings on the stones from which they were to be printed, shared the north side of the fourth floor at No. 33 Spruce Street with the artists. Their role in producing salable lithographs was an exacting one. Duplicating an oil painting on a textured stone surface—in reverse—with greasy, black crayons of varying thickness and hardness was a task that permitted few mistakes and hardly any erasures. Even accidentally touching the stone with a sweaty fingertip could leave an impression sure to appear as a smudge in the finished print. Nevertheless, lines gone astray in unimportant areas of a design could be scraped from the stone, but it was not possible to rethink a line, remove it, and then

redraw it. A serious mistake meant that the stone had to be reground. Some of the regular artists, like Louis Maurer and Fanny Palmer, were expert lithographers as well, but generally the job of putting a drawing or painting "on stone" called for talents beyond the mere artistic—such as patience, concentration, and a steady hand. Even a small stone was likely to take longer than a week to prepare for printing.

The entire fifth floor of the Currier & Ives factory was devoted to brightly hand-coloring the black-ink lithographs produced on the third and fourth floors. The work was in the skilled hands of a supervisor and a dozen or so talented young immigrant girls (mostly German) with some kind of earlier artistic training. They were seated at arm's length from each other at long worktables, and each young lady was instructed to apply a single color to a print in all the areas it was to appear before sliding it along to the next girl—and the next color. Eventually the evolving picture would reach a senior colorist entrusted with handling the most difficult passages, who would also touch up earlier work where necessary. There was always a model print to follow that the original artist or Fanny Palmer had colored to the satisfaction of one of the partners. However, this assembly-line process was restricted to producing the cheaper small- and medium-sized prints, and in times of heavy demand its output could be significantly increased. For instance, in rushing to get a Civil War battle scene on the market while the news was still fresh, a back-up force of less-skilled girls was called in to apply preliminary coloring by stenciling washes over broad areas—a line of boldly charging Union troops might have all their uniforms colored blue in one brushstroke! The effects of these washes were supplemented by the regular girls, who would more carefully paint the prominent figures and add touches of bright color to battle flags, bleeding wounds, and muzzle blasts before passing the print on to the finisher. After all, not much effort could be profitably spent on a product meant to wholesale at just six cents apiece.

The large prints (averaging about two feet by three feet) were always sent out for coloring to well-trained artists who specialized in this work. However, even they were given a fully colored model approved by Currier or Ives to follow. Usually the colorists were given a dozen plain prints at a time, and, at mid-century, the fee to be earned for coloring them was a dollar a dozen. These large prints (done by the firm's best artists) generally retailed from $1.50 to $3.00, depending on their complexity or their market, but occasionally they went as high as $6.00. Today, a rare and desirable print such as "The Life of a Hunter. 'A Tight Fix' " would bring over ten thousand dollars if it ever came up at auction.

Nathaniel Currier continued to resist all advice to "modernize" his operation with facilities for actually printing the company's famous lithographs in color. Chromolithography, as the new color process was called, had made great advances in the 1860s, but Currier remained devoted to the hand-coloring that had served the firm so well. After all, Currier & Ives was still America's most popular printmaker: "our Prints have become a staple article . . . in great demand in every part of

the country." "In fact," as a catalog of 1872 boasted, "without an exception, all that we have published for the past thirty-eight years (and they comprise several thousand) have met with a quick and ready sale."

IN 1872, CURRIER & IVES gave up its retail shop of thirty-four-years' duration for smaller quarters at 125 Nassau Street. Two years later, the firm had moved into 123 Nassau, and, three years after that, in 1877, it was operating out of 115 Nassau, where it remained for another seventeen years. In 1880, Nathaniel Currier, then sixty-seven years old, retired from the famous company founded by him nearly fifty years earlier. The prosperous half-century he had spent in lithography also had been a period of fantastic development and change for the hundred-year-old American republic. Its westernmost frontier had moved in that time from the Missouri River all the way to the Pacific Ocean. The population of a still-growing America had more than tripled—from fifteen million to fifty million. New York, the nation's largest city, had burgeoned from 300,000 to 1,200,000 inhabitants. To reach the Pacific coast was a journey that consumed months, whether by prairie schooner across the Great Plains or, in the 1850s, by noble clipper ship around the Horn; in 1880 it took only six days by transcontinental railroad. Up to 1835, there had been no such thing as illustrated news; no quick way for the man in the street to grasp the horror of a distant catastrophe; no way that the urban mechanic could easily picture what a buffalo looked like (or a Mississippi River sidewheel steamboat); no way for a matron of modest circumstances to afford a colorful print for her parlor; no easy way for a Middle Border schoolmarm to help her pupils visualize the exciting events of our nation's founding. However, Nathaniel Currier had a hand in changing all of that.

"Old Hickory" was still President when Currier launched his series of "Cheap and Popular" prints—the first colorful and artistic pictures a Jacksonian "common man" could ever afford to own. The simple nature and wide variety of these prints over the years incidentally schooled our citizens in what it meant to be American. Currier's dramatic historical pictures brought to life for everyone the stirring highlights of America's proud beginnings (as well as contemporary battles of the Mexican and Civil wars). His innovative political banners effectively met the widespread public's need to know what its leading presidential candidates looked like, and the company's topical cartoons offered (as they were advertised) a democratic selection of "hits at the weak points of all the candidates, policies and parties." The many city and landscape views issued by Currier & Ives presented Americans with a wide-ranging panorama of the manmade and natural wonders of their remarkable country; and the clipper ship, locomotive, steamship, and yacht prints testified

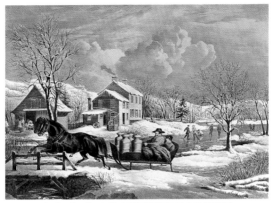

American Farm Scenes. No. 4. Nathaniel Currier, 1853. (F. F. Palmer).

to the American genius for inventing and perfecting, and to their love of speed. There were also bucolic scenes of planting and harvest, reminding the harried city-dweller of man's natural (and more perfect?) state; as well as provocative prints of Barnum freaks and notorious entertainers like Lola Montez, tempting the bumpkins to visit the "sinful" city; and "Comic Colored Pictures" that would "drive away the blues, and promote health by hearty and wholesome laughter." The sportsman or armchair adventurer was treated to sylvan scenes of comradeship and hunting in the Adirondacks, to jolly fishing trips on Long Island Sound, to prints of important horse races and other sporting events, and to the romance of panning gold in the Sierra Nevada and of following our westward expansion through lands roamed by wild Indians and buffalo. The ladies were offered a wide selection of tasteful flower and fruit pictures to ornament the dining room, and awesome landscapes for the parlor; they were kept abreast of the latest styles on Fifth Avenue by fashion plates, and had their moral sensibilities touched by a steady outpouring of religious and temperance prints and by gentle scenes that called to mind their innocent childhoods.

Nathaniel Currier had retired at a time when there was yet some justification in the boast that

Currier & Ives's "Celebrated Mammoth Catalogue" offered "The Best, the Cheapest, and the Most Popular Pictures in the World." Although undated, this catalog was issued from the 115 Nassau Street address of 1877 to 1894, and it still presented a grand total of 1,412 different prints. There are later catalogs bearing the company's next address, 108 Fulton Street, but by then the swell of popular demand that Currier & Ives had ridden so skillfully was well past its crest. Even at the peak of the firm's success, a wave of the future was building rapidly, a wave that eventually washed away the old underpinnings of the hand-colored lithograph. It was not a tidal wave that arrived without warning; its signs were clearly visible for a long time. Currier had them pointed out more than once, but perhaps most poignantly in an incident reported to Harry T. Peters by Ives's son Chauncey. One day in the 1860s, Currier's old friend P. T. Barnum strode into 152 Nassau Street with the midget Tom Thumb perched on his shoulder, a sure way to attract the public's attention. Barnum was there to discuss a new lithographed portrait of his tiny sideshow attraction to use in promotion. In the middle of the conversation, Thumb interrupted: "Barnum," he said, "I have a better idea. Let's go uptown to Sarony's, and I'll pose for a photo. He does all the big boys, and these old lithos are out of date."

Indeed, during the late 1860s photographic portraits by Mathew Brady, Napoleon Sarony, and others had become a social necessity, and a collecting mania for carte-de-visite photographs of the famous was well underway. At his death in 1896, Napoleon Sarony, the most fashionable portraitist of the time, left a collection of 40,000 photographs of actors and actresses, not to mention 170,000 portraits of notables in other fields. Earlier, in the 1850s, another exciting invention of growing popularity had entered the market, a device that caused especially paired photographs to appear in three dimensions when viewed through its eyepiece. By 1863, one firm, E. & H. T. Anthony & Company, offered more than 1,100 examples of America's famous sights and natural wonders for viewing by stereoscope, or stereopticon. Also in the 1850s, lively illustrated periodicals began to appear with wood-engravings more timely, more numerous, and more skillfully done than ever before—magazines like *Harper's* and *Gleason's Pictorial Drawing-Room Companion* and *Frank Leslie's Illustrated Newspaper*. The significant advantages still held for a time by Currier & Ives prints in portraiture, scenic views, and pictorial coverage of the news were their vivid coloring and low price. However, these final attractions were greatly diminished by the perfecting of chromolithography in the 1860s and rapid improvements in steam-powered printing, which by 1871 had brought forth a press capable of 1,800 impressions per hour.

O N NOVEMBER 20, 1888, seventy-five-year-old Nathaniel Currier succumbed to heart disease at his home, 28 West 27th Street, in New York City. His place in the business had been filled in 1880 by his son Edward West Currier, who was trained as a lawyer. James Merritt Ives died, at the age of seventy-one, on January 3, 1895, at his home in Rye, New York. His remains were taken to Brooklyn for burial in Green-Wood Cemetery, where his former business partner had been interred seven years earlier. Chauncey Ives assumed his father's role at the old firm, and in 1896 its retail shop was closed and its main office moved into the factory building on Spruce Street. The last-known dated prints with the famous Currier & Ives imprint were issued in 1898 and covered events of the Spanish-American War. By 1902, the firm's activities were consolidated on but one floor of the factory building, and Edward West Currier had transferred his interests in the company to Chauncey Ives. In 1907, after a period of too gradually reducing the company's inventory of lithographs, Chauncey Ives sold the business to Daniel W. Logan, Jr., son of the firm's long-term sales manager. Later in that same year, Logan disposed of the remaining prints by the bundle, the stones by the pound, and dismantled the outmoded equipment that once had produced America's Best, Cheapest, and Most Popular Pictures!

Novus Ordo Seclorum

("A New Era is Born")

—GREAT SEAL OF THE UNITED STATES

WILLIAM PENN'S TREATY WITH THE INDIANS WHEN HE FOUNDED
THE PROVINCE OF PENNSYLVANIA 1661

THE LANDING OF THE PILGRIMS AT PLYMOUTH, MASS. DEC. 22nd 1620

FRANKLIN'S EXPERIMENT, JUNE 1752

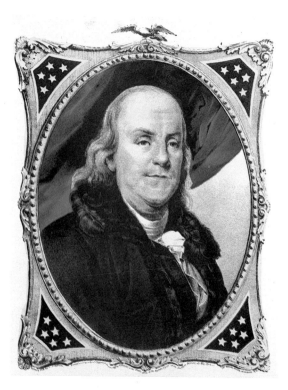

BENJAMIN FRANKLIN / THE STATESMAN AND PHILOSOPHER

THE DESTRUCTION OF TEA AT BOSTON HARBOR

BATTLE AT BUNKER'S HILL

WASHINGTON CROSSING THE DELAWARE

WASHINGTON'S ENTRY INTO NEW YORK

SURRENDER OF LORD CORNWALLIS

THE INAUGURATION OF WASHINGTON

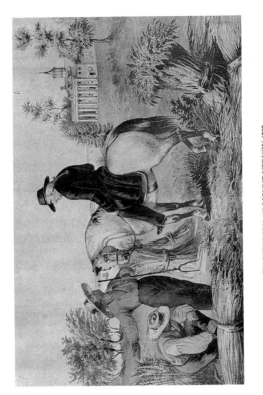

WASHINGTON AT MOUNT VERNON 1797

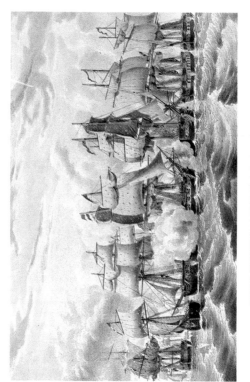

PERRY'S VICTORY ON LAKE ERIE / FOUGHT SEPT. 10th, 1813

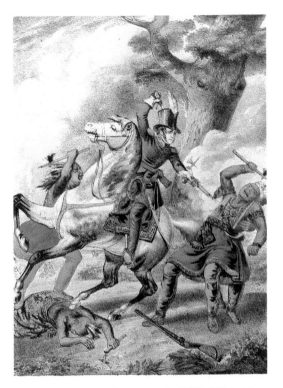

DEATH OF TECUMSEH / BATTLE OF THE THAMES OCT. 18, 1813

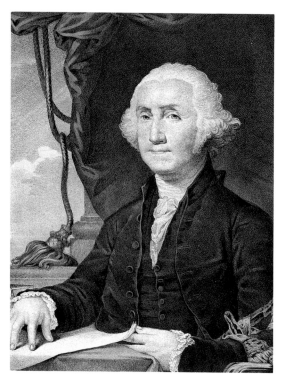

GEORGE WASHINGTON / FIRST PRESIDENT OF THE UNITED STATES

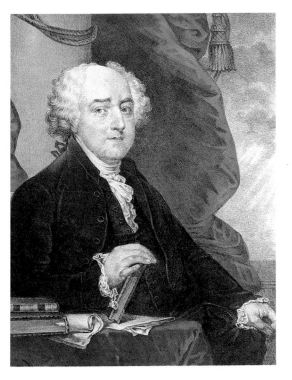

JOHN ADAMS / SECOND PRESIDENT OF THE UNITED STATES

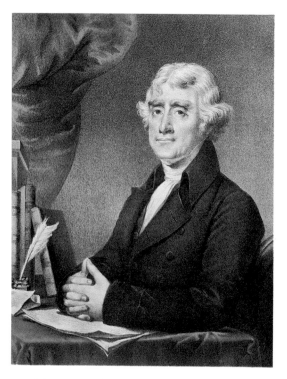

THOMAS JEFFERSON / THIRD PRESIDENT OF THE UNITED STATES

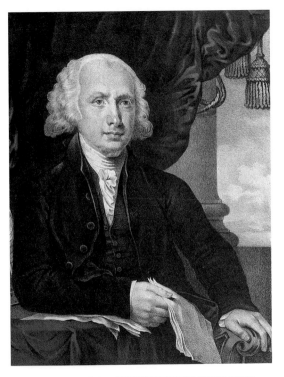

JAMES MADISON / FOURTH PRESIDENT OF THE UNITED STATES

CLIPPER SHIP "NIGHTINGALE"

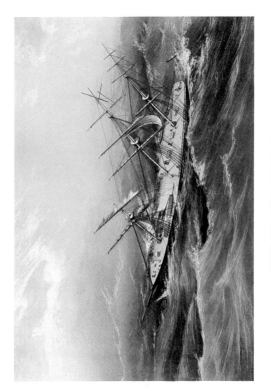

CLIPPER SHIP "COMET" OF NEW YORK

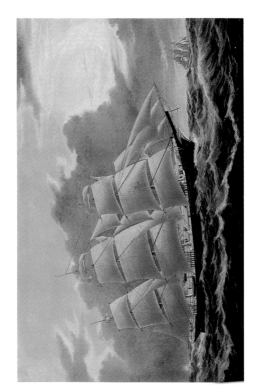

CLIPPER SHIP "DREADNOUGHT" OFF TUSKAR LIGHT

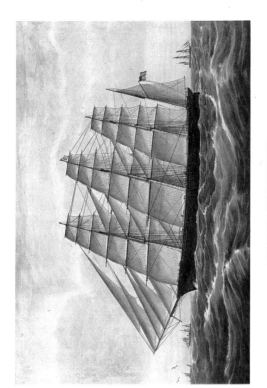

CLIPPER SHIP "GREAT REPUBLIC"

THE BARK "THEOXENA"

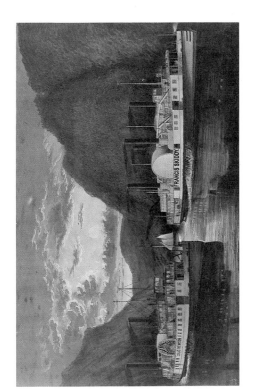

A NIGHT ON THE HUDSON / "THROUGH AT DAYLIGHT"

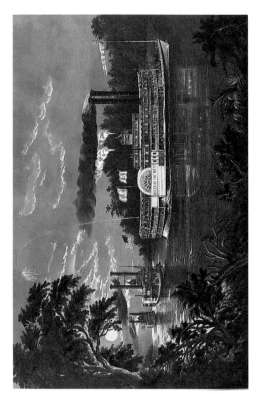

"ROUNDING A BEND" ON THE MISSISSIPPI / THE PARTING SALUTE

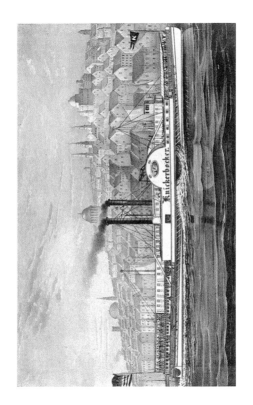

STEAM-BOAT "KNICKERBOCKER"

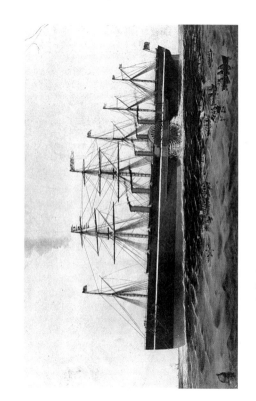

THE IRON STEAM SHIP "GREAT EASTERN" 22,500 TONS

STEAM CATAMARAN—H. W. LONGFELLOW

THE ELECTRIC LIGHT / THOMAS EDISON AND C. F. BRUSH

"Proud and passionate city!
mettlesome, mad extravagant city!"

—WALT WHITMAN, "CITY OF SHIPS"

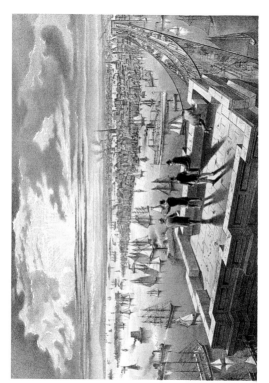

THE HARBOR OF NEW YORK / FROM THE BROOKLYN BRIDGE TOWER

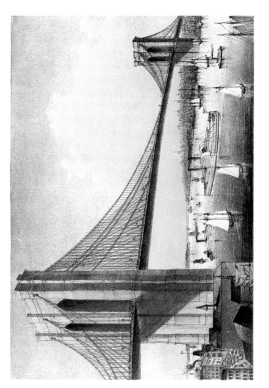

THE GREAT EAST RIVER SUSPENSION BRIDGE

NEW YORK CRYSTAL PALACE

VIEW OF NEW YORK / FROM WEEHAWKEN.— NORTH RIVER

BLACKWELL'S ISLAND, EAST RIVER

THE HIGH BRIDGE AT HARLEM, N. Y.

STATEN ISLAND AND THE NARROWS

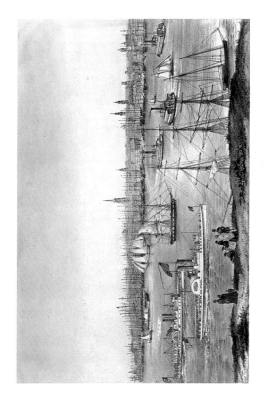

VIEW OF NEW YORK / FROM BROOKLYN HEIGHTS

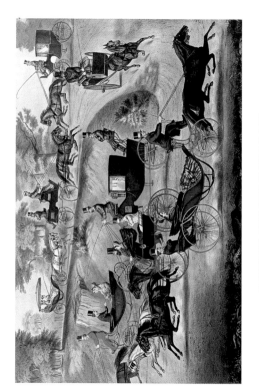

FASHIONABLE "TURN-OUTS" IN CENTRAL PARK

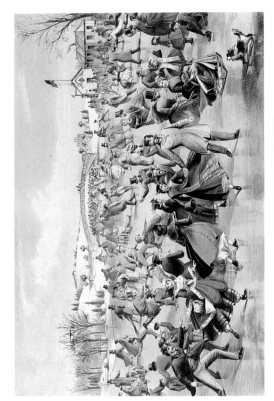

CENTRAL-PARK WINTER / THE SKATING POND

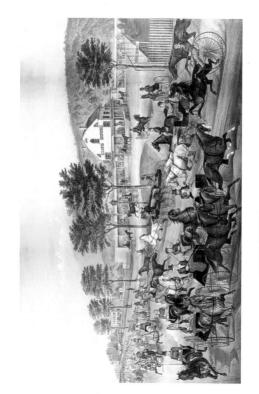

FAST TROTTERS ON HARLEM LANE, N. Y.

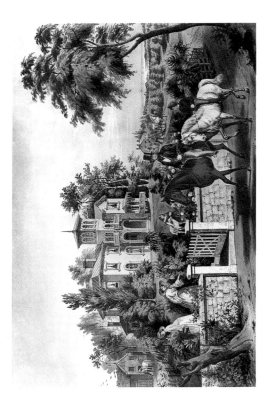

AMERICAN COUNTRY LIFE. MAY MORNING

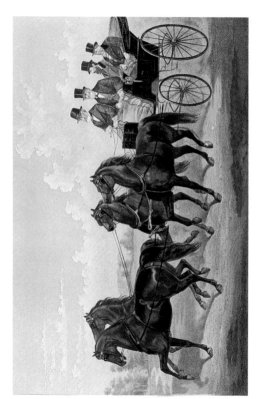

THE CELEBRATED "FOUR IN HAND" STALLION TEAM

LIFE IN THE COUNTRY. THE MORNING RIDE

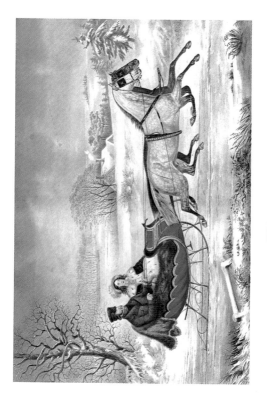

THE ROAD—WINTER

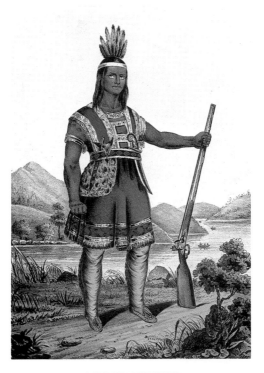

E. FORREST AS METAMORA

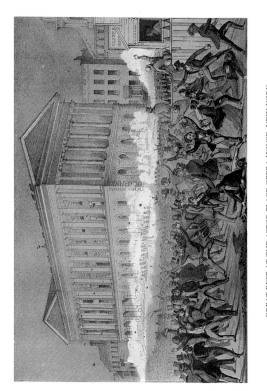

GREAT RIOT AT THE ASTOR PLACE OPERA HOUSE, NEW YORK

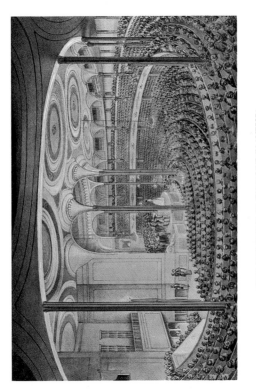

FIRST APPEARANCE OF JENNY LIND IN AMERICA

UPPER AND LOWER BAY OF NEW YORK

THE BELLE OF THE WEST

SARAH BERNHARDT

SUMMER SCENES IN NEW YORK HARBOR

THE CHINESE JUNK "KEYING"

THE SMOKER'S PROMENADE

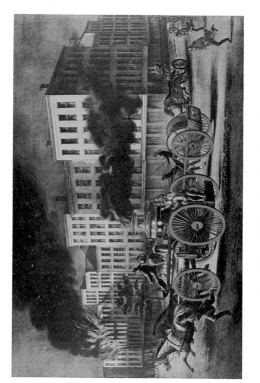

THE LIFE OF A FIREMAN. THE METROPOLITAN SYSTEM

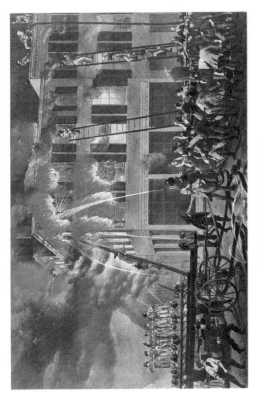

THE LIFE OF A FIREMAN. THE FIRE

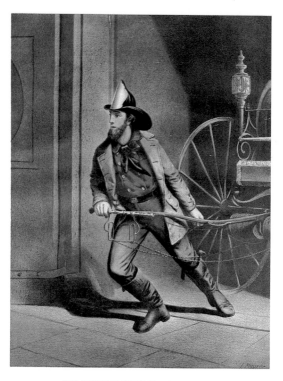

THE AMERICAN FIREMAN, ALWAYS READY

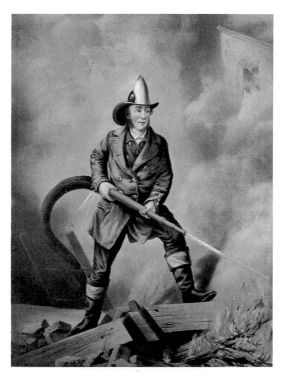

THE AMERICAN FIREMAN, FACING THE ENEMY

"How dear to my heart
are the scenes of my childhood"

—SAMUEL WOODWORTH, "THE OLD OAKEN BUCKET" (1818)

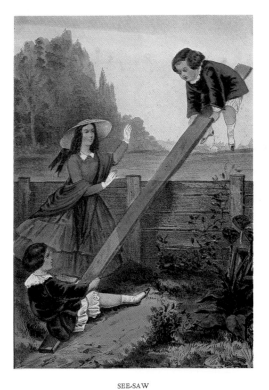

SEE-SAW

THE WONDERFUL STORY / "THE NAUGHTY WOLF LEAPED
UPON THE GOOD WOMAN AND ATE HER UP."

THE NEW BROOD

SAFE SAILING

LITTLE SISTERS

THE KNITTING LESSON

THE BURNING GLASS

THE LITTLE BEAU

LITTLE SNOWBIRD

THE FAVORITE CAT

MY LITTLE WHITE BUNNIES RECEIVING A VISITOR

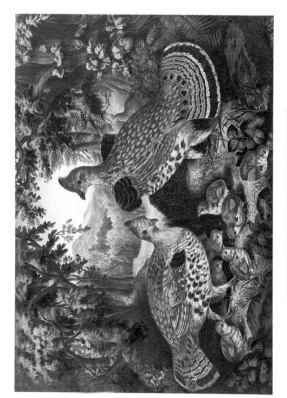

THE HAPPY FAMILY. RUFFED GROUSE AND YOUNG

A RISING FAMILY

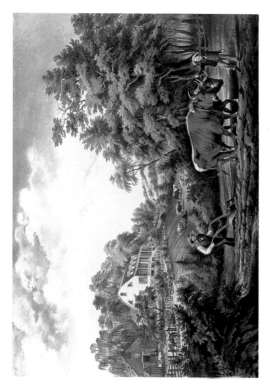

AMERICAN FARM SCENES. / NO. 1

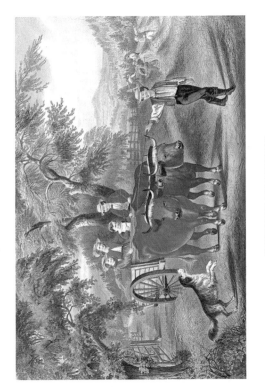

HAYING-TIME. THE FIRST LOAD

HAYING-TIME. THE LAST LOAD

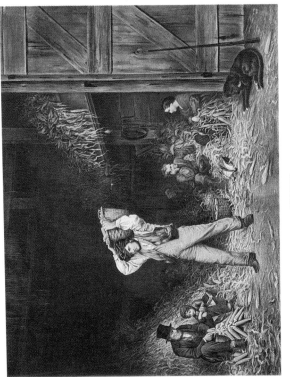

HUSKING

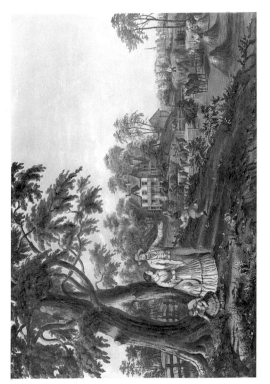

AMERICAN COUNTRY LIFE. SUMMER'S EVENING

THE OLD BARN FLOOR

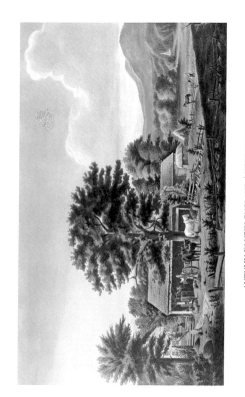

AUTUMN IN NEW ENGLAND / CIDER MAKING

PREPARING FOR MARKET

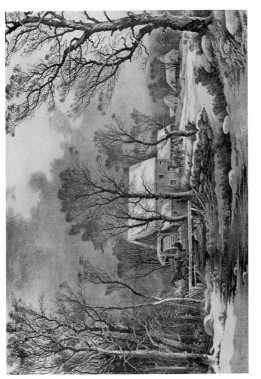

WINTER IN THE COUNTRY / THE OLD GRIST MILL

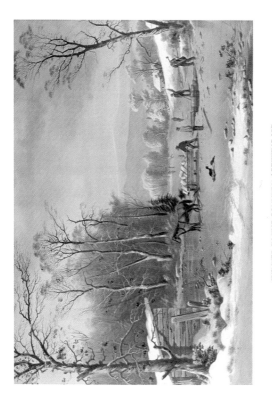

WINTER IN THE COUNTRY / GETTING ICE

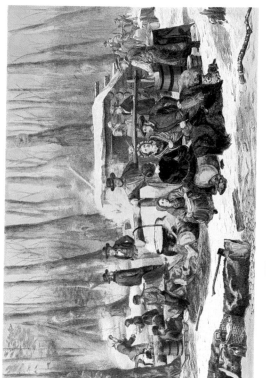

AMERICAN FOREST SCENE / MAPLE SUGARING

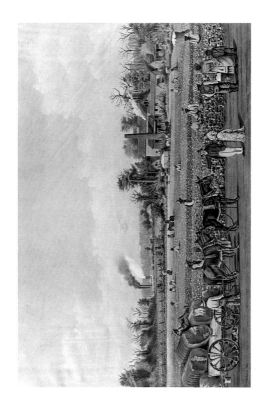

A COTTON PLANTATION ON THE MISSISSIPPI

THE RIVER SHANNON / FROM THE TOWER OF LIMERICK CATHEDRAL

STRATFORD ON AVON

GLENGARIFF INN, IRELAND

"... our manifest destiny to overspread
the continent allotted by Providence"

—JOHN L. O'SULLIVAN, DEMOCRATIC REVIEW" (1845)

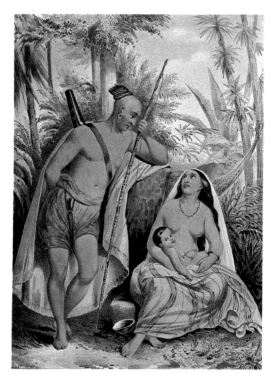

THE INDIAN FAMILY

HIAWATHA'S WEDDING

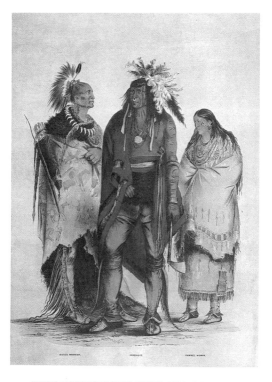

NORTH AMERICAN INDIANS / OSAGE, IROQUOIS, PAWNEE

THE SNOW-SHOE DANCE

THE INDIAN BEAR DANCE

INDIANS ATTACKING THE GRIZZLY BEAR

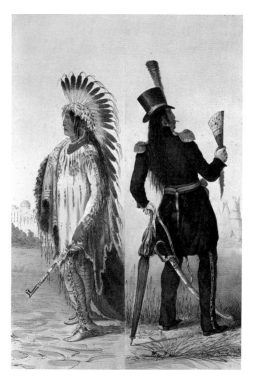

WI-JUN-JON—THE PIGEON'S EGG HEAD / GOING TO
WASHINGTON. RETURNING TO HIS HOME.

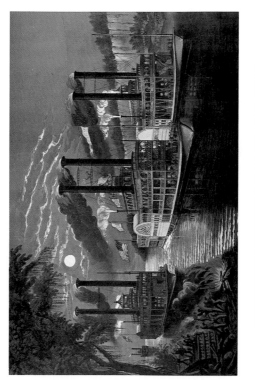

THE CHAMPIONS OF THE MISSISSIPPI / "A RACE FOR THE BUCKHORNS"

THROUGH THE BAYOU BY TORCHLIGHT

"WOODING UP" ON THE MISSISSIPPI

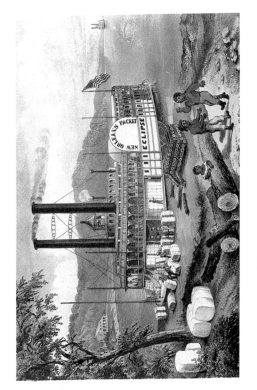

BOUND DOWN THE RIVER

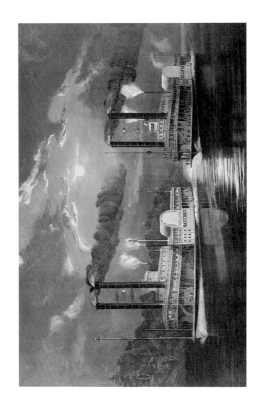

A MIDNIGHT RACE ON THE MISSISSIPPI

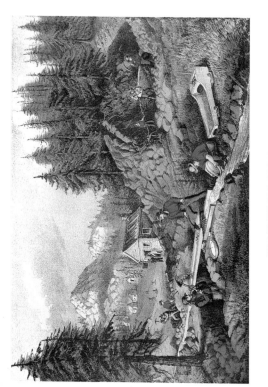

GOLD MINING IN CALIFORNIA

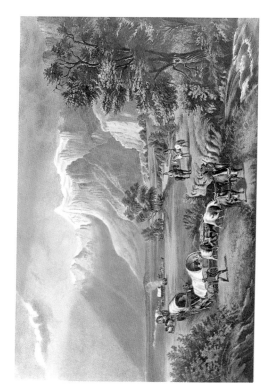

THE ROCKY MOUNTAINS / EMIGRANT'S CROSSING THE PLAINS

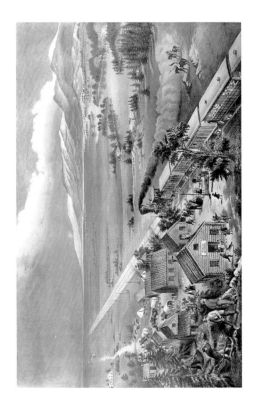

ACROSS THE CONTINENT / "WESTWARD THE COURSE OF EMPIRE TAKES ITS WAY"

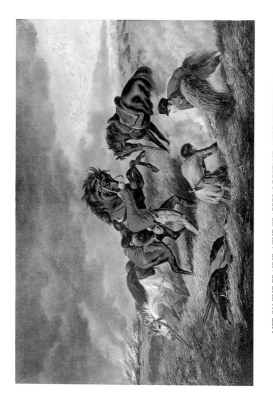

LIFE ON THE PRAIRIE / THE TRAPPER'S DEFENSE, "FIRE FIGHT FIRE"

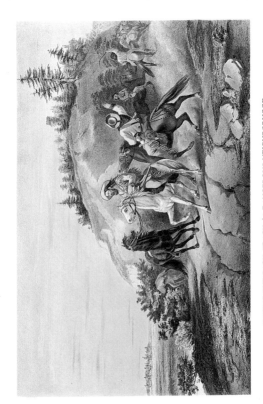

TAKING THE BACK TRACK / A DANGEROUS NEIGHBORHOOD

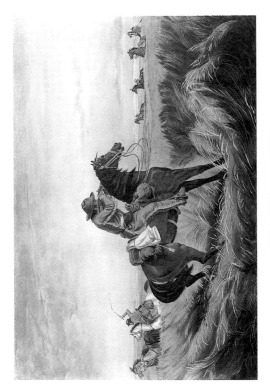

A CHECK. "KEEP YOUR DISTANCE!"

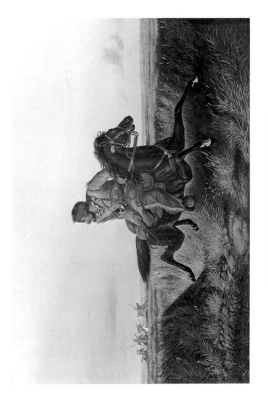

THE PRAIRIE HUNTER. "ONE RUBBED OUT!"

THE LAST WAR-WHOOP

LIFE ON THE PRAIRIE / THE "BUFFALO HUNT"

THE EXPRESS TRAIN

AMERICAN EXPRESS TRAIN

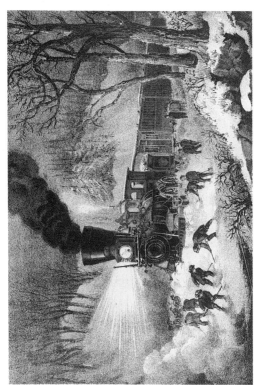

AMERICAN RAILROAD SCENE / SNOW BOUND

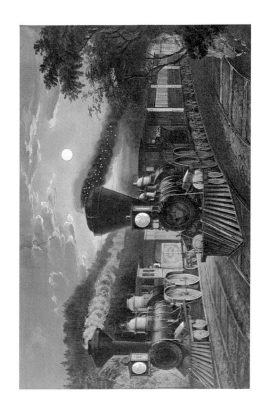

THE "LIGHTNING EXPRESS" TRAINS / "LEAVING THE JUNCTION"

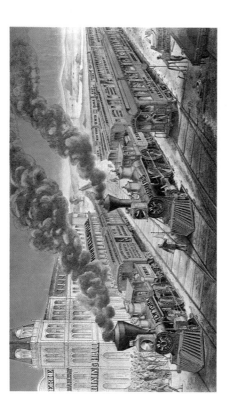

AN AMERICAN RAILWAY SCENE, AT HORNELLSVILLE, ERIE RAILWAY

"Be it ever so humble,
there's no place like home"

—JOHN HOWARD PAYNE, "HOME, SWEET HOME" (1823)

HOME TO THANKSGIVING

HOME, SWEET HOME

THE FARMER'S HOME—HARVEST

MY COTTAGE HOME

A HOME IN THE COUNTRY

AMERICAN HOMESTEAD WINTER

A HOME ON THE MISSISSIPPI

A NEW ENGLAND HOME

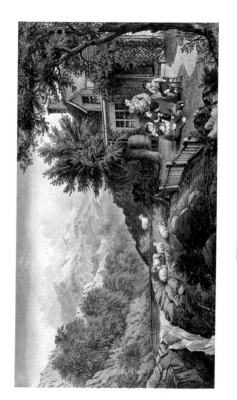

THE MOUNTAINEER'S HOME

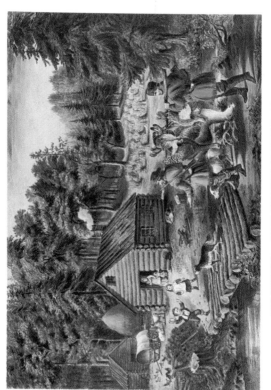

THE PIONEER'S HOME / ON THE WESTERN FRONTIER

THE WESTERN FARMER'S HOME

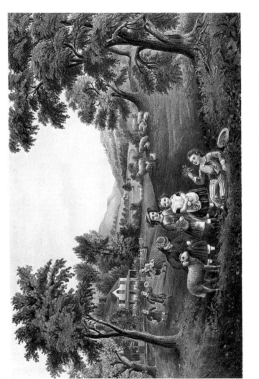

THE FOUR SEASONS OF LIFE: CHILDHOOD / "THE SEASON OF JOY"

THE FOUR SEASONS OF LIFE: YOUTH /"THE SEASON OF LOVE"

THE FOUR SEASONS OF LIFE: MIDDLE AGE / "THE SEASON OF STRENGTH"

THE FOUR SEASONS OF LIFE: OLD AGE / "THE SEASON OF REST"

THE LOVERS QUARREL

THE LOVERS RECONCILIATION

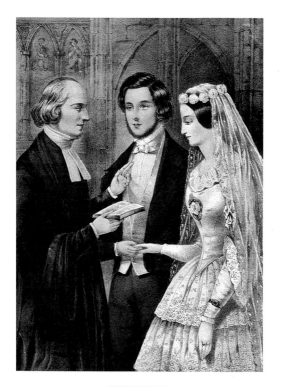

THE MARRIAGE

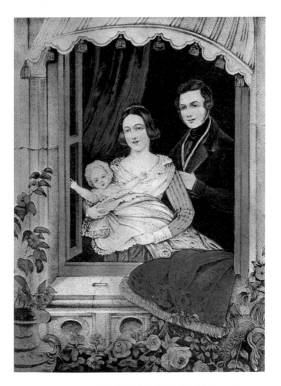

THE YOUNG HOUSEKEEPERS / A YEAR AFTER MARRIAGE

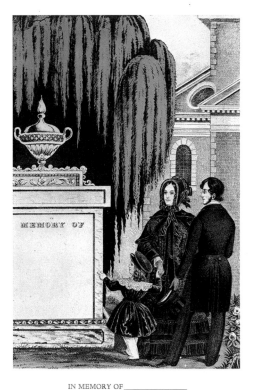

IN MEMORY OF _____

SPRING FLOWERS

GARDEN, ORCHARD AND VINE

AUTUMN FRUITS

THE PUZZLED FOX / FIND THE HORSE, LAMB, WILD BOAR, MEN'S AND WOMEN'S FACES

PUZZLE PICTURE. OLD SWISS MILL.

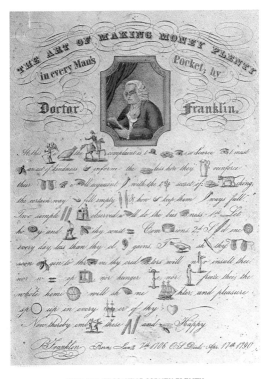

THE ART OF MAKING MONEY PLENTY

"Thou, too, sail on, O Ship of State!
Sail on, O Union, strong and great!"

—HENRY WADSWORTH LONGFELLOW, "BUILDING OF THE SHIP" (1849)

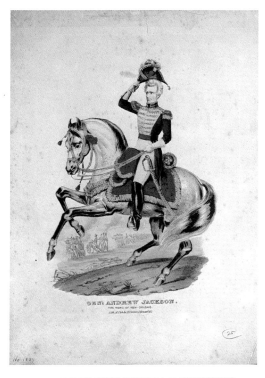

GEN. ANDREW JACKSON.
THE HERO OF NEW ORLEANS.

No 182?

25

GEN. ANDREW JACKSON / THE HERO OF NEW ORLEANS

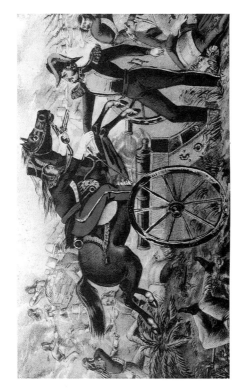

BATTLE OF RESACA DE LA PALMA, MAY 9th 1846

SIEGE OF VERA CRUZ MARCH 1847

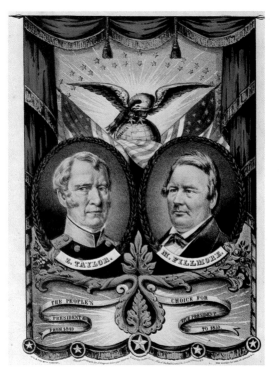

GRAND, NATIONAL, WHIG BANNER / PRESS ONWARD

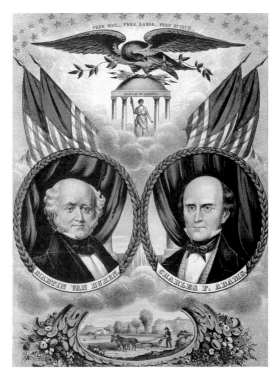

GRAND DEMOCRATIC FREE SOIL BANNER

DEATH OF GENERAL Z. TAYLOR / 12th PRESIDENT OF THE UNITED STATES

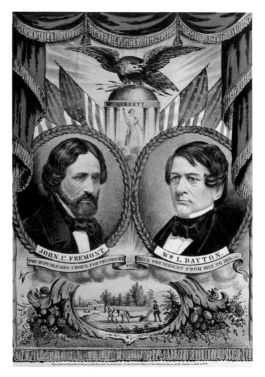

GRAND NATIONAL REPUBLICAN BANNER / FREE LABOR,
FREE SPEECH, FREE TERRITORY

ARGUING THE POINT

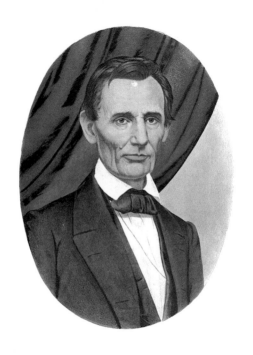

HON. ABRAHAM LINCOLN

BOMBARDMENT OF FORT SUMTER, CHARLESTON HARBOR

THE LEXINGTON OF 1861

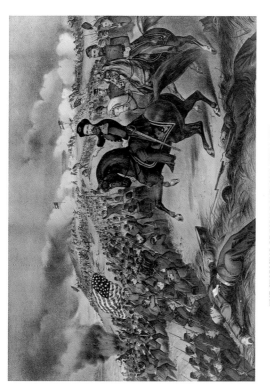

THE STORMING OF FORT DONELSON, TENN. FEB. 15th 1862

TERRIFIC COMBAT BETWEEN THE "MONITOR" 2 GUNS & "MERRIMAC" 10 GUNS

BOMBARDMENT AND CAPTURE OF ISLAND "NUMBER TEN"

THE MISSISSIPPI IN TIME OF WAR

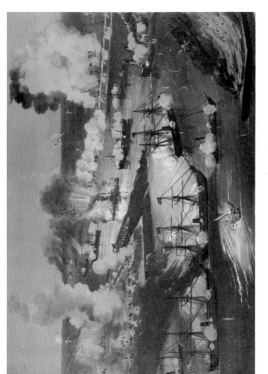

THE SPLENDID NAVAL TRIUMPH ON THE MISSISSIPPI

THE BATTLE OF FAIR OAKS, VA. MAY 31st 1862

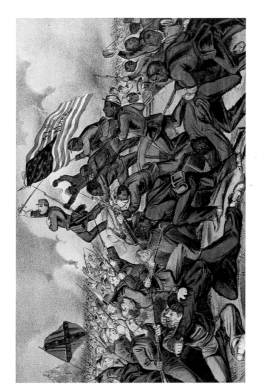

THE GALLANT CHARGE OF THE FIFTY-FOURTH MASSACHUSETTS (COLORED) REGIMENT

LIGHT ARTILLERY

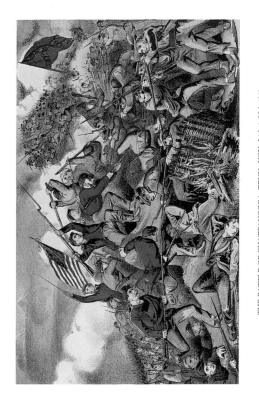

THE BATTLE OF CHATTANOOGA, TENN. NOV. 24th & 25th 1863

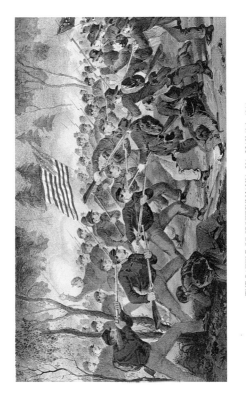

THE BATTLE OF SPOTTSYLVANIA, VA. MAY 12th, 1864

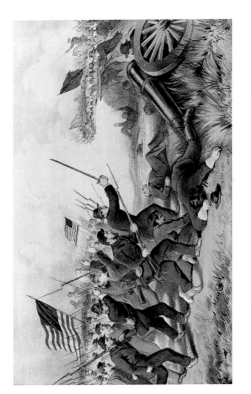

THE BATTLE OF JONESBORO, GEORGIA, SEPT. 1st, 1864

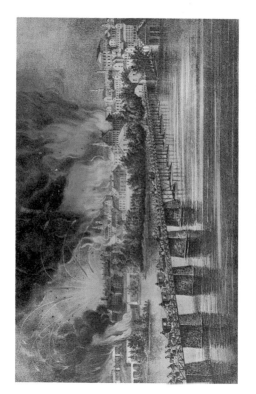

THE FALL OF RICHMOND VA. ON THE NIGHT OF APRIL 2nd, 1865

THE ATTACK ON THE 'HOME GUARD'

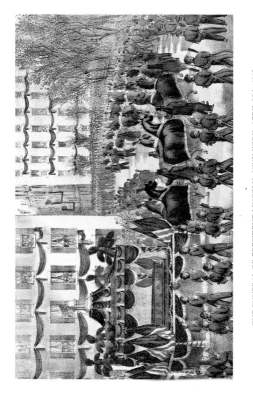

THE FUNERAL OF PRESIDENT LINCOLN, NEW YORK, APRIL 25th, 1865

1876—ON GUARD / "UNCEASING VIGILANCE IS THE PRICE OF LIBERTY"

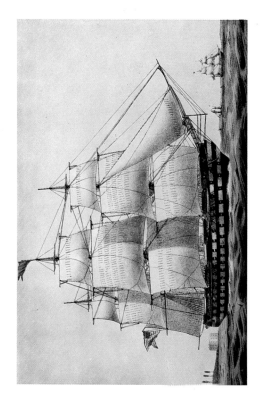

U. S. SHIP OF THE LINE OHIO, 104 GUNS

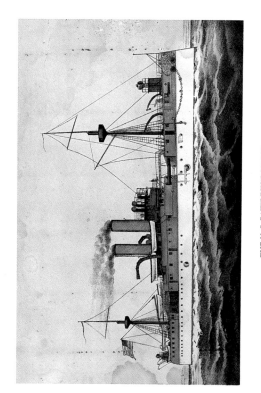

THE U. S. BATTLESHIP MAINE

"Go forth, under the open sky,
and list to Nature's teachings."

—WILLIAM CULLEN BRYANT "THANATOPSIS" (1817)

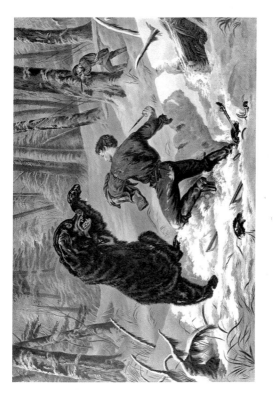

THE LIFE OF A HUNTER / "A TIGHT FIX"

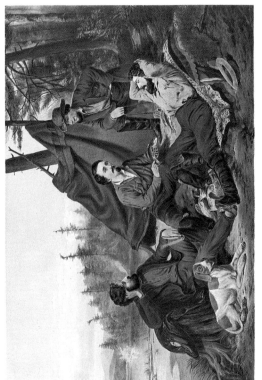

CAMPING IN THE WOODS / "LAYING OFF"

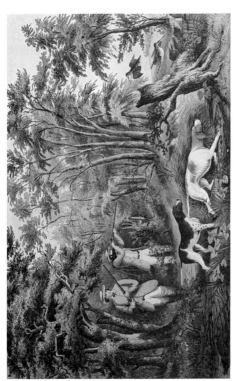

WOODCOCK SHOOTING

PARTRIDGE SHOOTING

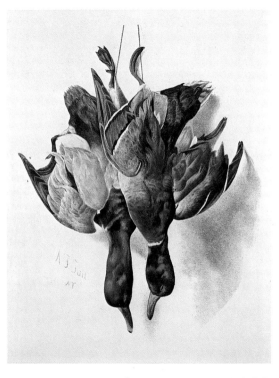

AMERICAN FEATHERED GAME / MALLARD AND CANVAS BACK DUCKS

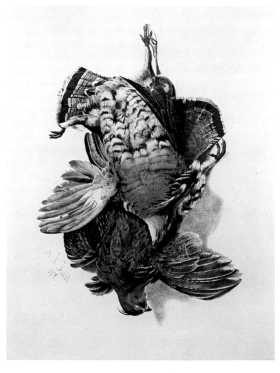

AMERICAN FEATHERED GAME / PARTRIDGES

WILD DUCK SHOOTING

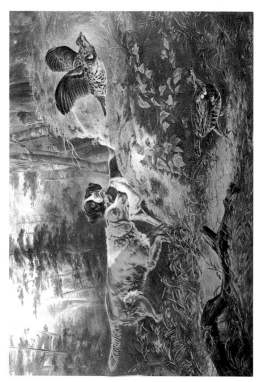

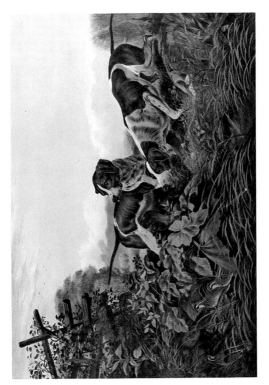

AMERICAN FIELD SPORTS / "ON A POINT"

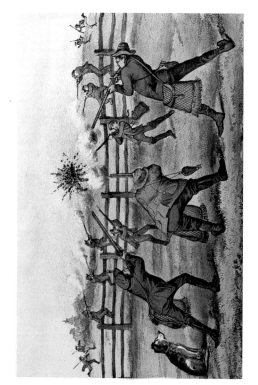

THE FIRST BIRD OF THE SEASON

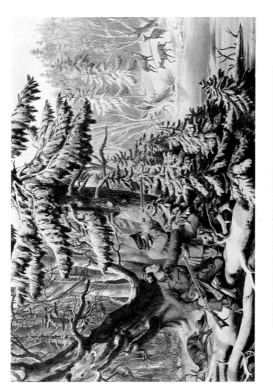

AMERICAN WINTER SPORTS / DEER SHOOTING "ON THE SHATTAGEE"

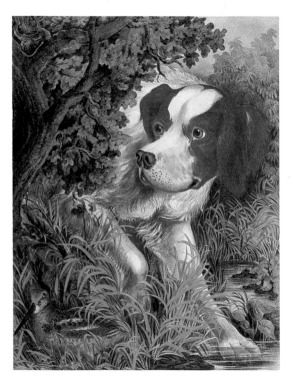

CLOSE QUARTERS

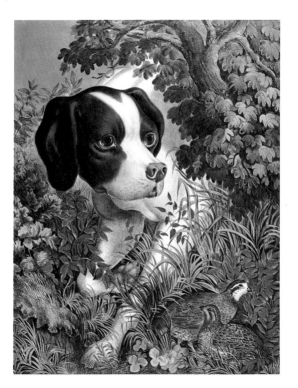

POINTING A BEVY

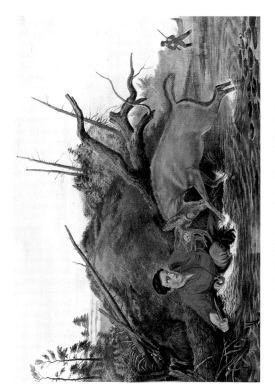

THE LIFE OF A HUNTER. "CATCHING A TARTAR"

MINK TRAPPING / "PRIME"

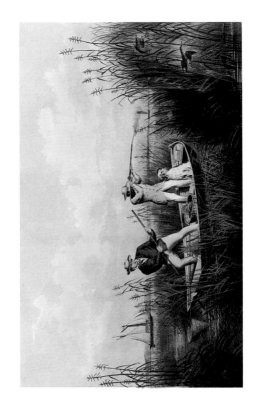

RAIL SHOOTING / ON THE DELAWARE

BEACH SNIPE SHOOTING

WILD DUCK SHOOTING / A GOOD DAY'S SPORT

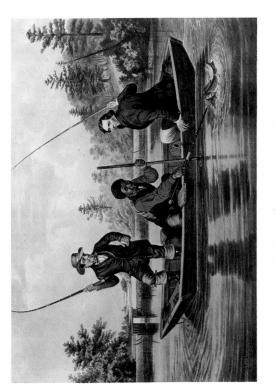

CATCHING A TROUT / "WE HAB YOU NOW, SAR!"

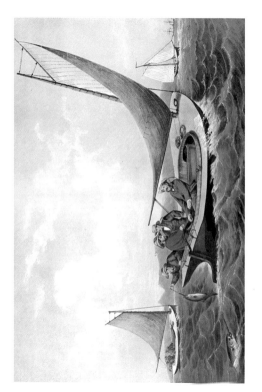

TROLLING FOR BLUE FISH

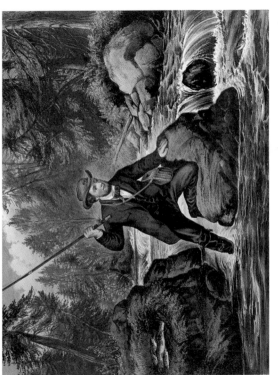

AN ANXIOUS MOMENT / "A THREE POUNDER SURE"

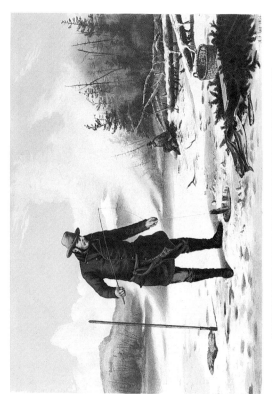

AMERICAN WINTER SPORTS / TROUT FISHING "ON CHATEAUGAY LAKE"

CAUGHT ON THE FLY

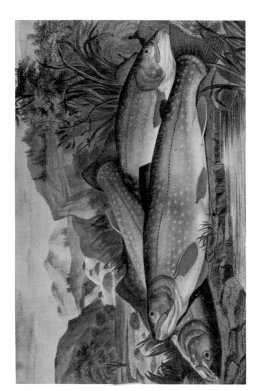

BROOK TROUT—JUST CAUGHT

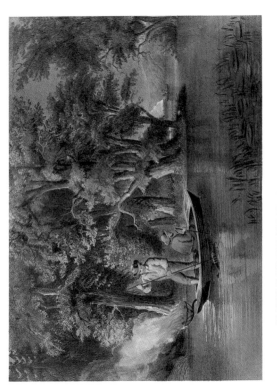

BLACK BASS SPEARING / ON THE RESTIGOUCHE, NEW BRUNSWICK

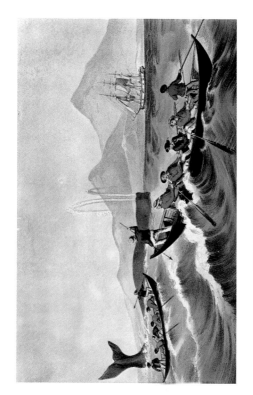

THE WHALE FISHERY "LAYING ON"

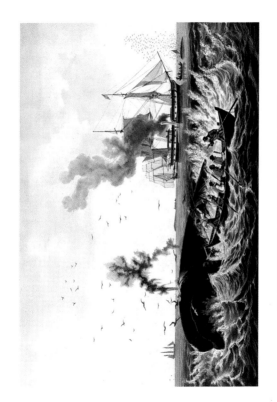

THE WHALE FISHERY, THE SPERM WHALE IN A FLURRY

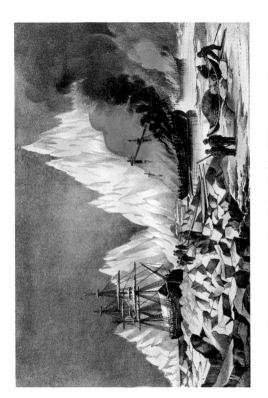

AMERICAN WHALERS CRUSHED IN THE ICE / "BURNING THE WRECKS
TO AVOID DANGER TO OTHER VESSELS"

"...America is a poem in our eyes:
its ample geography dazzles the imagination"

—RALPH WALDO EMERSON

THE FALLS OF NIAGARA / "FROM THE CANADA SIDE"

NORTHERN SCENERY

THE RIVER ROAD

SILVER CASCADE

AMONG THE HILLS

GEMS OF AMERICAN SCENERY

NEWPORT BEACH

THE FLORIDA COAST

LANDSCAPE CARDS

VIEW DOWN THE RIVER

THE FALLS

VIEW UP THE RIVER

LAKE WINNIPISEOGEE

VIEW ON THE HUDSON

SARATOGA LAKE

ECHO LAKE

SUNNYSIDE

PUBLISHED BY McLOUGHLIN & SONS

519 NASSAU ST., NEW YORK

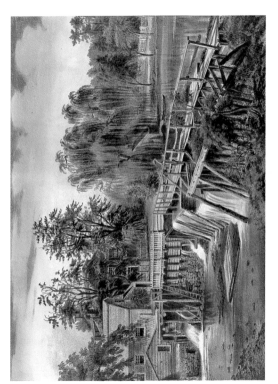

THE MILLDAM AT "SLEEPY HOLLOW"

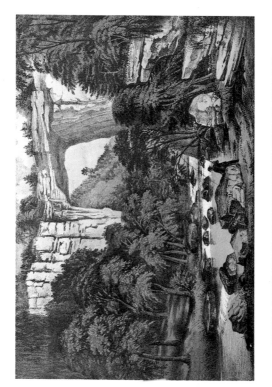

NATURAL BRIDGE / IN THE "BLUE RIDGE" REGION, ROCKLAND COUNTY, VA.

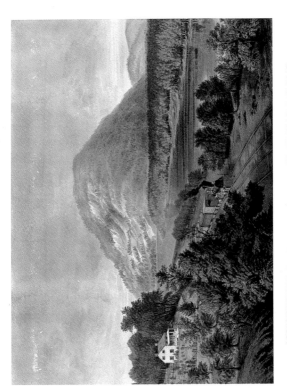

LOOKOUT MOUNTAIN, TENNESSEE / AND THE CHATTANOOGA RAIL ROAD

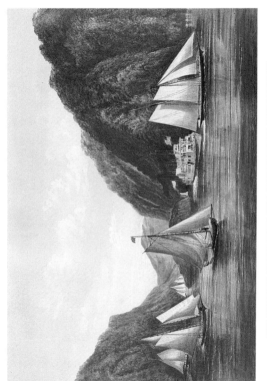

THE ENTRANCE TO THE HIGHLANDS / HUDSON RIVER LOOKING SOUTH

VIEW OF BALTIMORE

VIEW OF BOSTON

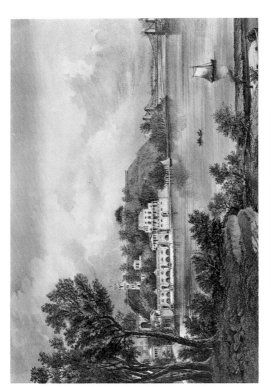

FAIRMOUNT WATER WORKS / PHILADELPHIA

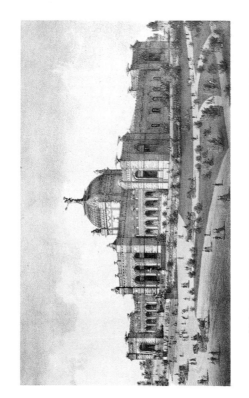

ART GALLERY / GRAND UNITED STATES CENTENNIAL EXHIBITION, 1876

EARLY WINTER

THE AMBUSCADE

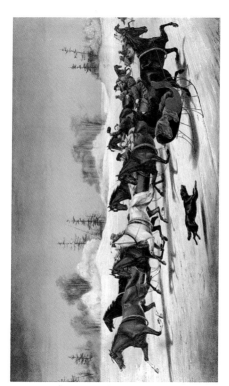

"TROTTING CRACKS" ON THE SNOW

THE SNOW STORM

WINTER IN THE COUNTRY: A COLD MORNING

WINTER EVENING

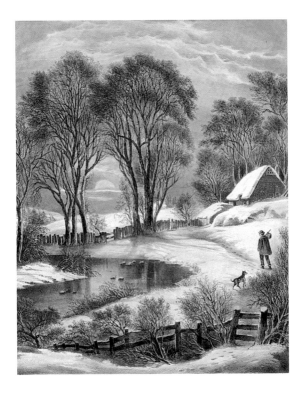

WINTER MOONLIGHT

CENTRAL PARK IN WINTER

THE VILLAGE BLACKSMITH

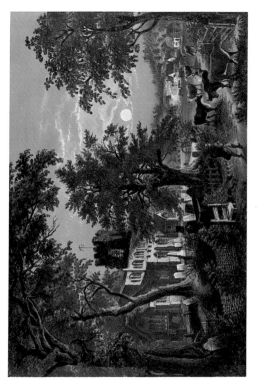

GRAY'S ELEGY / IN A COUNTRY CHURCH YARD

THE OLD OAKEN BUCKET

ENOCH ARDEN—THE LONELY ISLE

THE WAYSIDE INN

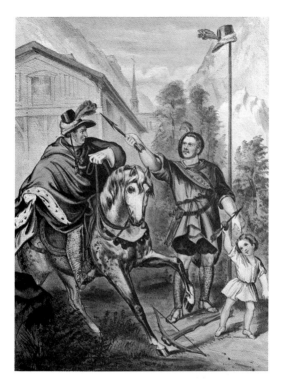

WILLIAM TELL / REPLY TO THE GOVERNOR

"Never was such horseflesh as in those days on Long Island or in the City"

WALT WHITMAN

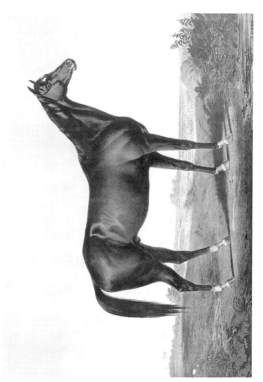

THE CELEBRATED HORSE LEXINGTON

PEYTONA AND FASHION

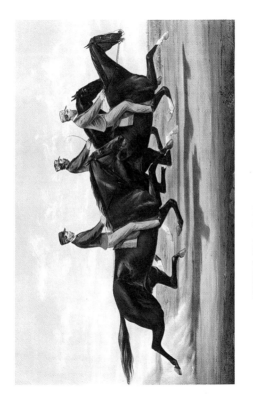

TORONTO CHIEF, GENERAL BUTLER, AND DEXTER

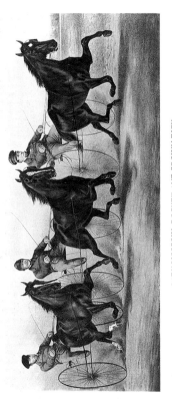

LADY MOSCOW, ROCKET AND BROWN DICK

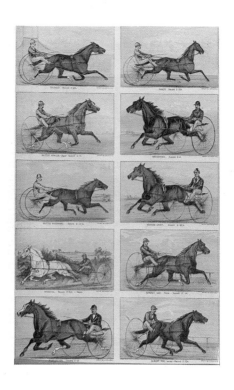

UNCUT SHEET OF TROTTER CARDS

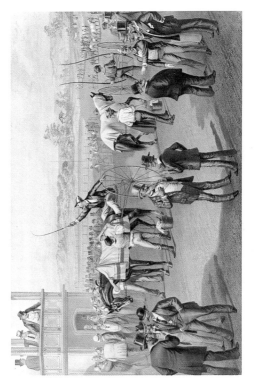

A DISPUTED HEAT / CLAIMING A FOUL!

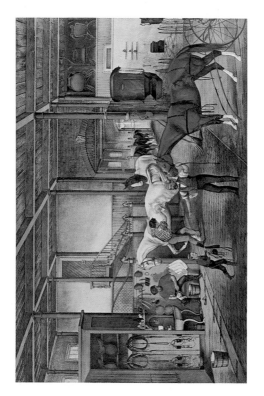

"TROTTING CRACKS" AT HOME / A MODEL STABLE

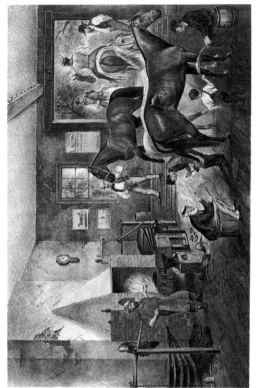

"TROTTING CRACKS" AT THE FORGE

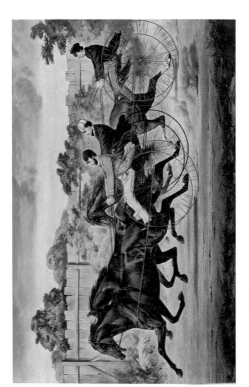

GEORGE M. PATCHEN, BROWN DICK AND MILLER'S DAMSEL

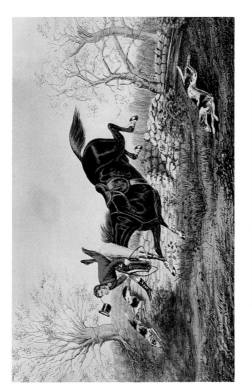

HUNTING CASUALTIES, DISPATCHED TO HEAD QUARTERS

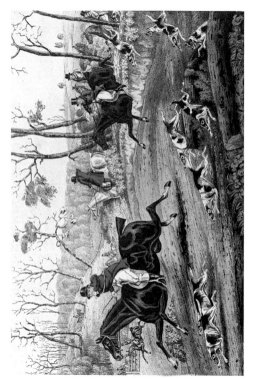

FOX CHASE / GONE AWAY

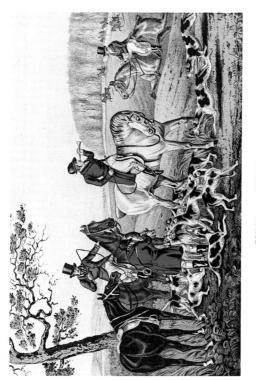

FOX CHASE / THE DEATH

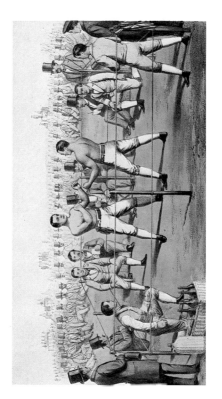

THE GREAT FIGHT FOR THE CHAMPIONSHIP

YANKEE DOODLE ON HIS MUSCLE

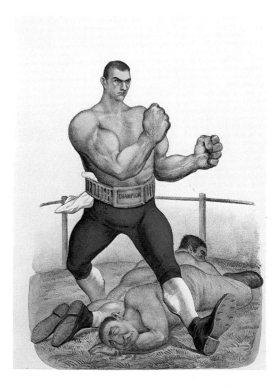

THE CHAMPION SLUGGER / "KNOCKING 'EM OUT"

SLUGGED OUT / "BETTER LUCK NEXT TIME"

THE VELOCIPEDE / "WE CAN BEAT THE SWIFTEST STEED, WITH OUR NEW VELOCIPEDE"

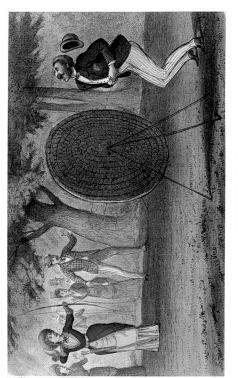

BENDING HER BEAU!

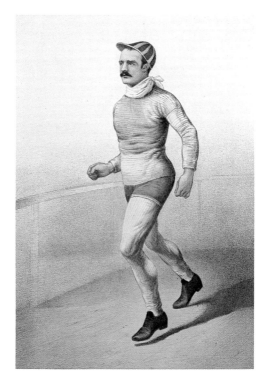

CHARLES ROWELL / THE CELEBRATED PEDESTRIAN

THE AMERICAN NATIONAL GAME OF BASE BALL

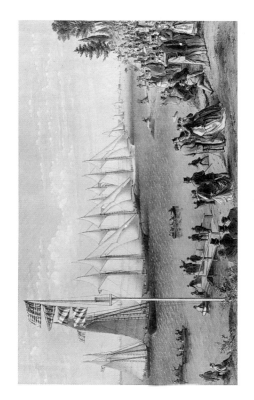

THE NEW YORK YACHT CLUB REGATTA

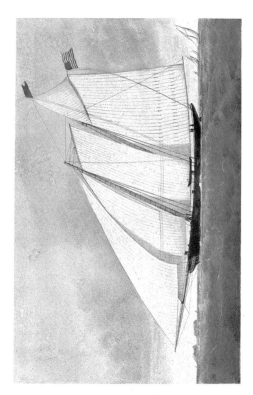

THE CLIPPER YACHT "AMERICA" OF NEW YORK

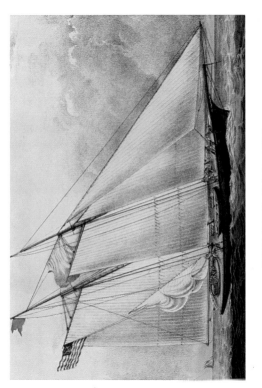

YACHT "METEOR" OF N. Y. 293 TONS

"VOLUNTEER"

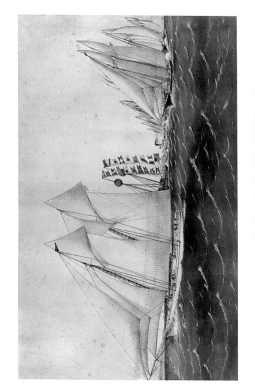

THE GREAT INTERNATIONAL YACHT RACE, AUGUST 8, 1870

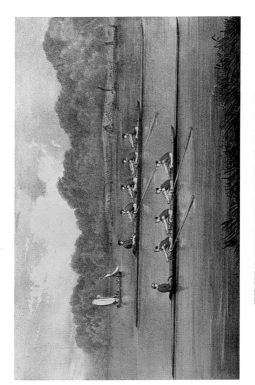

THE GREAT INTERNATIONAL BOAT RACE, AUG. 27th, 1869

ICE-BOAT RACE ON THE HUDSON

"...ev'ry prospect pleases,
and only man is vile"

—LOWELL MASON, "FROM GREENLAND'S ICY MOUNTAINS" (1836)

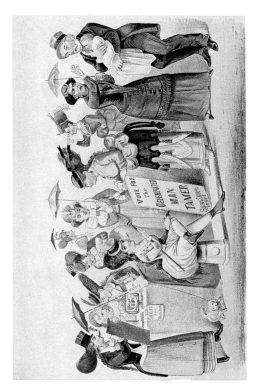

THE AGE OF IRON / MAN AS HE EXPECTS TO BE

THE GIRL OF THE PERIOD

THE BLOOMER COSTUME

"THE GRECIAN BEND" / FIFTH AVENUE STYLE

JOSEPHINE

ELLEN

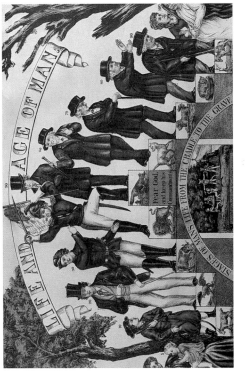

LIFE AND AGE OF MAN

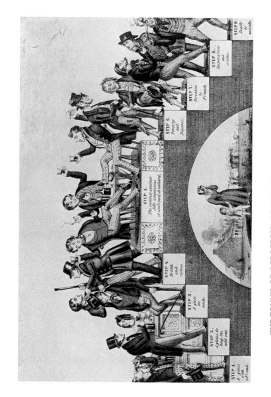

THE DRUNKARD'S PROGRESS / FROM THE FIRST GLASS TO THE GRAVE

READING THE SCRIPTURES

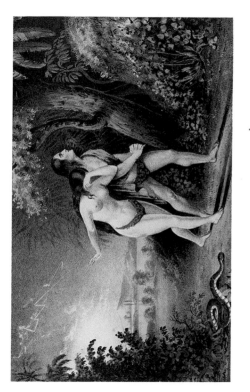

ADAM AND EVE DRIVEN OUT OF PARADISE

JERUSALEM / FROM THE MOUNT OF OLIVES

NOAH'S ARK

SHAKERS NEAR LEBANON

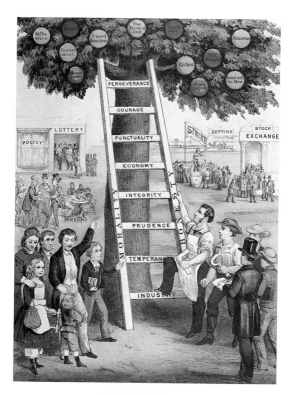

THE LADDER OF FORTUNE

"NO ONE TO LOVE ME"

THE CREAM OF LOVE

LOVE IS THE LIGHTEST

KISS ME QUICK

A KISS IN THE DARK

SOLDIER'S RETURN

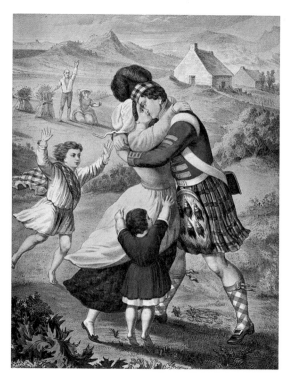

THE HIGHLANDER'S RETURN

THE DREAMS OF YOUTH

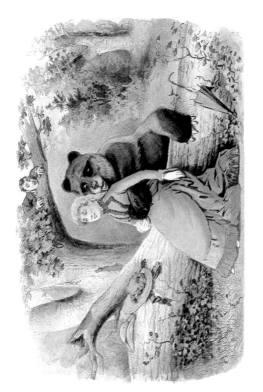

HUG ME CLOSER, GEORGE!